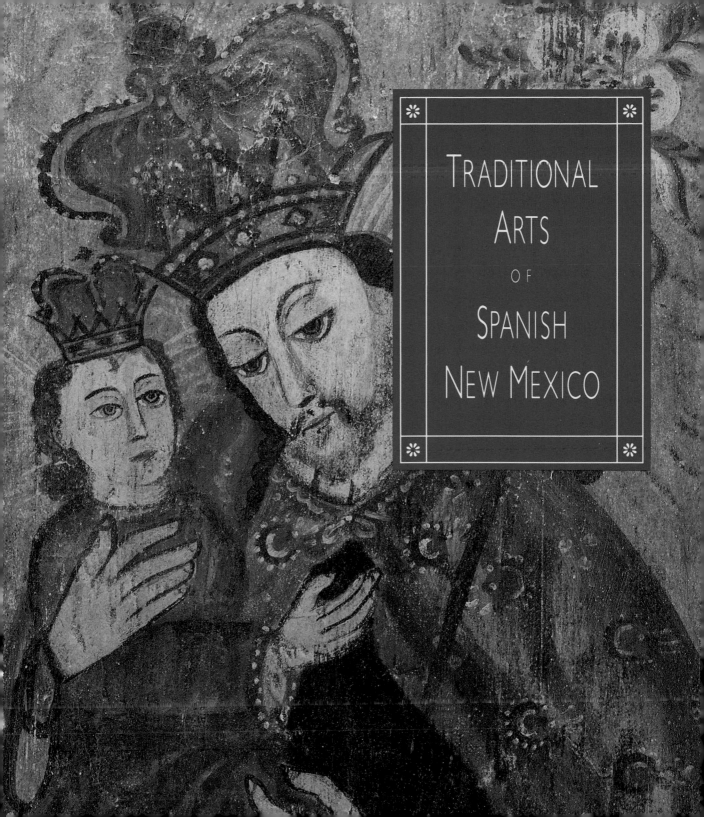

TRADITIONAL

ARTS

OF

SPANISH

NEW MEXICO

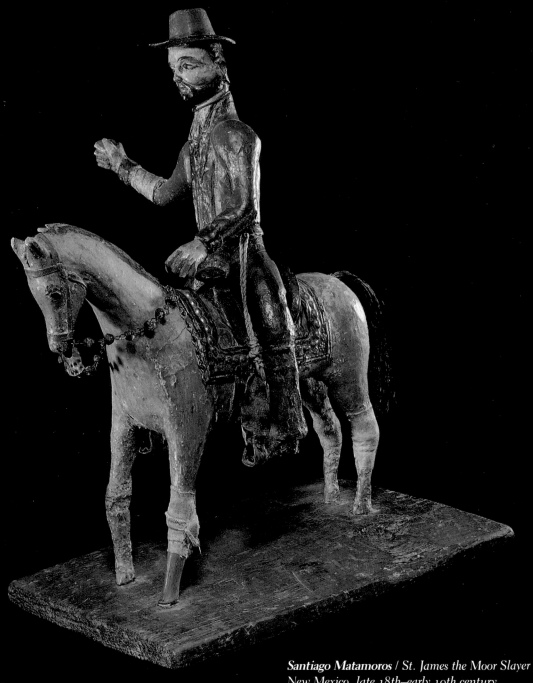

Santiago Matamoros / St. James the Moor Slayer
New Mexico, late 18th–early 19th century.
Gesso and water-soluble paint, metal and leather on
wood, 14½ × 10⁵⁄₁₆ in., SCAS

TRADITIONAL ARTS
OF
SPANISH
NEW MEXICO

THE HISPANIC HERITAGE WING AT THE
MUSEUM OF INTERNATIONAL FOLK ART

by Robin Farwell Gavin

MUSEUM OF NEW MEXICO PRESS
SANTA FE

FRONTISPIECE

This sculpture illustrates the ingenuity of the colonial artist in the reuse of materials. The reins for Santiago's horse have been fashioned from a rosary; his saddle was created from an old daguerreotype frame of wood and leather with metal studs; and he stands on a hand-adzed retablo *with a worn image of the Santo Niño de Atocha on the underside.*

All objects reproduced in this book are from Spanish colonial collections housed within the Museum of International Folk Art in Santa Fe, New Mexico. The following abbreviations found in the plate captions refer to the collections here noted:

ASF	Collection of the Archdiocese of Santa Fe
CDC	Bequest of Charles D. Carroll to the Museum of New Mexico
CW	Bequest of Cady Wells to the Museum of New Mexico
FH	Fred Harvey Collection of the International Folk Art Foundation
HSNM	Historical Society of New Mexico
IFAF	Collection of the International Folk Art Foundation
MNM	Collection of the Museum of New Mexico
SAR	Collection of the School of American Research
SCAS	Collection of the Spanish Colonial Arts Society, Inc.

The Museum of International Folk Art and the Museum of New Mexico Press are units of the Museum of New Mexico, a division of the State Office of Cultural Affairs.

Manufactured in Hong Kong

10 9 8 7 6 5 4 3 2

Project editor: Mary Wachs

Book design: Jos. Trautwein, The Bookmakers Studio

Typography: Set in Electra by Wilsted & Taylor, Oakland

Photography: Blair Clark

Library of Congress Cataloguing-in-Publication Data available.

ISBN: 0–89013–258–5

Museum of New Mexico Press
Post Office Box 2087
Santa Fe, New Mexico 87504

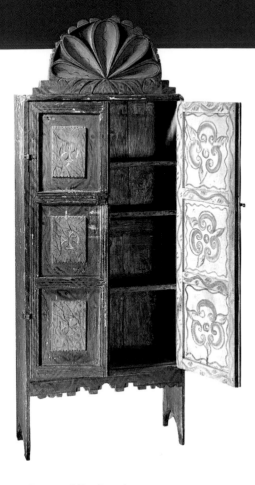

Trastero / *Cupboard*
New Mexico, 19th century.
*Gesso, water-soluble paint, and oil
paint on wood, 87¼ × 33¾ × 12¾ in.,*
SAR

*This cupboard is one of the few pieces from
the 1800s that retains historical painted
surfaces in good condition. The interior of
the cupboard, painted with water-soluble
pigments, reflects the style of the* santeros
working in the early to mid-1800s.

C O N T E N T S

✳

PREFACE

❋

In July 1989, the Museum of International Folk Art in Santa Fe, New Mexico, celebrated the inauguration of its Hispanic Heritage Wing, the first gallery of an American museum permanently dedicated to exhibiting traditional Hispanic arts, both colonial and contemporary.

The opening exhibit, *Familia y Fe* ("Family and Faith"), was conceived and written by Dr. William Wroth, guest curator, in collaboration with Dr. Helen Lucero, former curator of contemporary southwestern Hispanic art at the museum. The focus of that exhibit, and many of its objects, forms the heart of this publication, *Traditional Arts of Spanish New Mexico*.

The Hispanic Heritage Wing, the culmination of five years of planning, was designed to address a number of needs. First, it was in response to growing public demand for a place to showcase New Mexico's strong Hispanic artistic tradition. Meeting this need would enable the museum to highlight, through permanent and changing exhibits, its immense Spanish colonial art collection, among the country's largest with some seven thousand objects. The new wing would also provide space for the exhibition of works by twentieth-century Hispanic artists

working within a traditional framework—work that is usually excluded from exhibits in fine arts museums across the country. Finally, the timing of its opening exhibits coincided with the Columbian Quincentenary, of major significance to New Mexicans.

As an art historian, I feel privileged for the opportunity to study the Spanish colonial arts collection housed within the Museum of International Folk Art, and as a curator, I am honored to have been bestowed with its care. The knowledge I have of the pieces in the collection builds upon the years of study and contributions by others who have worked extensively with the collection. E. Boyd was the first to take a systematic approach to the study of New Mexican Spanish colonial art and built, along with Alan Vedder, the present collection. Dr. William Wroth studied the images of the *santos* with unprecedented depth, and Dr. Donna Pierce and Christine Mather were past curators of the collection and consistently presented it, in both publications and exhibits, with depth and clarity. Two organizations, the International Folk Art Foundation and the Spanish Colonial Arts Society, Inc., have consistently supported both acquisitions and research related to the collections housed at the Museum of International Folk Art. Through these efforts, and those of many others, the Spanish colonial arts of New Mexico have been raised from obscurity to an important and growing field of scholarship.

I am indebted to these individuals, most especially to Donna Pierce, and to Yvonne Lange, Charlie Carrillo, Felix López, and Joan Tafoya; the staff of the Museum of International Folk Art; Christopher Mead, Joe Rothrock, and Mary Grizzard at the University of New Mexico; and Josie Carruso, Pat Hall, Ann Day, and Catherine Drake. And I am grateful to my parents for teaching me to see, and to Jim, Molly, and Emma for keeping my eyes open. But my greatest appreciation goes to the artists and their work, for it is through their contributions that undocumented history about the Hispanic experience in colonial New Mexico is written.

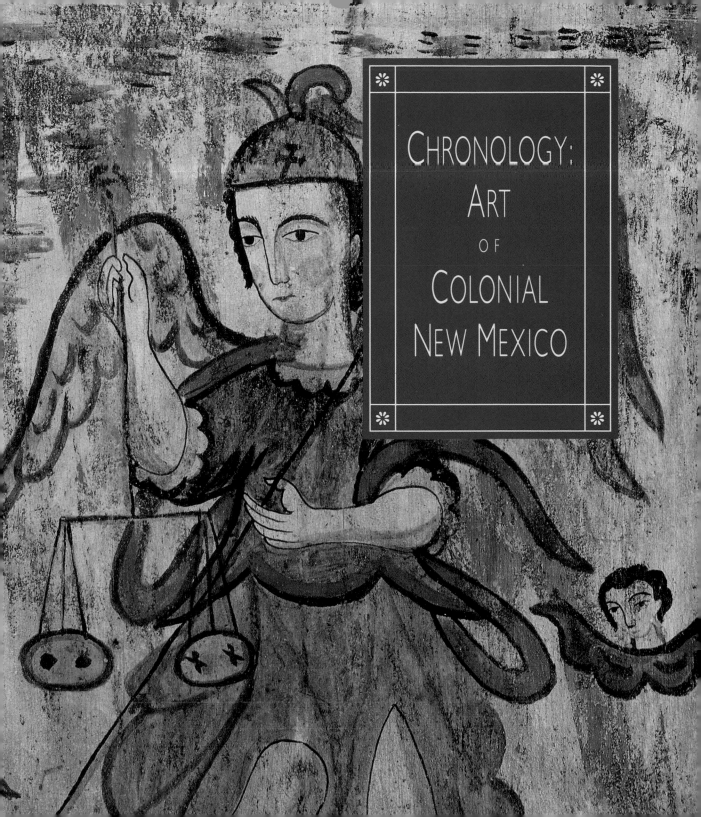

Chronology: Art of Colonial New Mexico

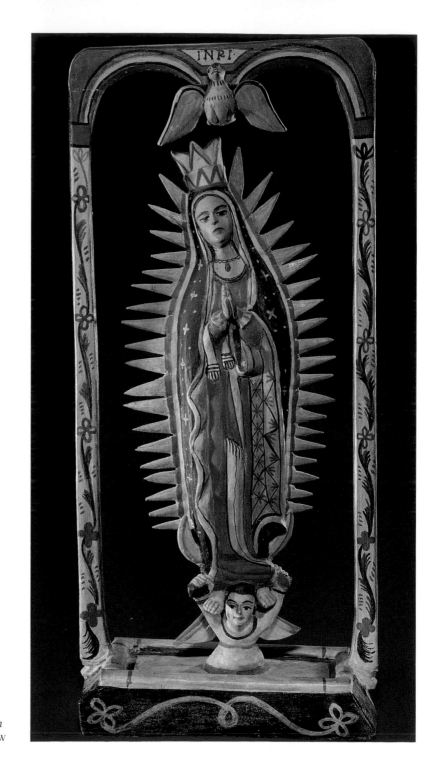

Nuestra Señora de Guadalupe /
Our Lady of Guadalupe
Rafael Aragón (ca. 1796–1862),
New Mexico, 1820–62.
Gesso and water-soluble paint on
wood, 24¾ × 11¼ × 5¼ in., CW

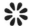

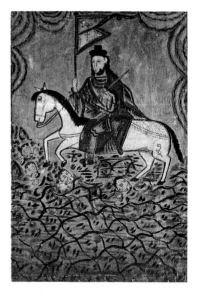

Santiago Matamoros / St. James
the Moor Slayer
Molleno, New Mexico,
1815–45.
Water-soluble paint on hide,
58¾ × 39³⁄₁₆ in., HSNM

As patron saint of Spain and one
of the twelve Apostles, Santiago's
aid was sought during the long
fight to expel the Moors. One leg-
end recounts that he miraculously
appeared to lead the Spanish Chris-
tians to victory in the Battle of
Clavijo when they were vastly out-
numbered by the Moors. In the
New World, Santiago was also very
popular and was similarly invoked
in battles with the Indians. In his
role as a slayer of Moors, Santiago
is shown as a knight on a white
horse. Generally, he holds a sword
in one hand and a white banner in
the other.

1519 Cortés lands in Vera Cruz, Mexico. Two years later, in 1521, he conquers the Aztec empire and the capital at Tenochtitlán; Mexico (New Spain) is officially pronounced a colony of Spain.

1523 Twelve Franciscans arrive at Vera Cruz, the first of a wave of missionaries who undertake to convert the natives of New Spain to Christianity.

1531 The Virgin Mary appears to the Indian peasant Juan Diego, the first native of Mexico so visited. His account is substantiated when the Virgin's image miraculously appears on his cape. A chapel is built to venerate the occurrence. It is upon this revered image with perceptibly darkened skin that all renderings of Mary as Our Lady of Guadalupe, the patroness of New Spain and Indian peoples, are based. The cape is still held today in the Basilica of Our Lady of Guadalupe in Mexico City.

1540 Coronado leads the first large expedition into New Mexico from New Spain and opens up the region to further exploration and settlement. New Mexico is claimed as part of the Spanish colonies. Churro sheep are first introduced to New Mexico.

1598 First Spanish colony established in New Mexico under Don Juan de Oñate at San Juan de los Caballeros (near present-day San Juan Pueblo). It is abandoned in 1610.

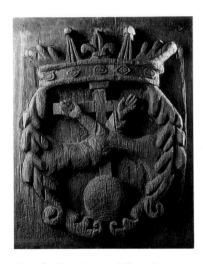

Escudo Franciscano / Franciscan Escutcheon
Bernardo Miera y Pacheco (d. 1785), New Mexico, 1754–85.
Gesso and oil on wood, 22¾ × 18½ in., ASF

The escutcheon, or arms, of the Franciscan Order shows the bare arm of Christ and the arm of St. Francis, clothed in the Franciscan habit, entwined in front of the Holy Cross. Both hands bear the stigmata—the wounds of Christ crucified—that St. Francis received during a mystic vision. This seal was used throughout the colonial period by the Franciscan Order and well into the 19th century. The door panel shown, once painted, is one of only two artifacts that are known to have survived from the 18th-century church at Santo Domingo Pueblo, destroyed by flood in 1886. The opposing door panel is painted with a corresponding coat of arms of the Bishop of Durango.

1599 St. James (Santiago) appears and divinely aids the Spanish colonists in their battle with the Indians at Acoma Pueblo.

1610 Santa Fe established as the capital of New Mexico under Don Pedro de Peralta. It is the oldest, continuously occupied capital city in the United States. (St. Augustine, Florida, was settled by the Spanish in 1565 and is the oldest, continuously occupied European community in the continental United States. Jamestown was settled in 1607 but was abandoned by 1700.)

Era of mission building begins in New Mexico. Between thirty to fifty mission churches were constructed over the next thirty years. Church architecture was based directly on Franciscan mission establishments in Mexico, and the missions were initially decorated with wall paintings and hide paintings that were replaced by altar screens and *retablos* as they were constructed or became available.

1616 New Mexico designated a Franciscan custody.

1626 Fray Alonso de Benavides arrives in Santa Fe with a statue from Spain of Our Lady of the Assumption. This image later becomes known as La Conquistadora. Today she is known as Our Lady of Peace.

1629 Official contract established for the mission supply caravans that had been operating since 1609. The caravan was scheduled to arrive in New Mexico every three years with supplies for the friars, including woodworking tools, cloth and clothing, Majolica pottery from Puebla, and church furnishings and ornamentation, such as oil paintings in gilded frames, crucifixes, and other carved images of Christ. These images were to be the prototypes for the later New Mexican *santos*.

1638 Textiles exported to Mexico.

1639	Silversmith Rodrigo Lorenzo, a Flemish artisan, is documented as living in Santa Fe.
1650s	The Solomonic baroque style becomes popular in Mexico in the decoration of church facades and altar screens. The column is derived from Bernini's baldachin in St. Peter's (1624–33).
1680	Pueblo Indians of New Mexico stage the only successful Indian revolt against European settlers in North America. Spanish colonists are driven south from New Mexico into El Paso del Norte, now Juárez, Mexico. Most of the homes, churches, and belongings of the colonists are destroyed.
1692–93	Don Diego de Vargas leads the reconquest of New Mexico, reoccupying the capital at Santa Fe and displacing its Pueblo inhabitants, and reestablishes Spanish rule.
1693	Blacksmith Bernardino Sena comes to Santa Fe from Mexico and sets up a shop that would be operated by his family for more than two centuries, well into the 1920s.
1695	*Villa* of Santa Cruz de la Cañada established by Vargas.
1706	*Villa* of Albuquerque established.
1707	Jesuit missionaries bring the Italian painting of Our Lady of Light to the Cathedral of León, in the state of Guanajuato, Mexico. This painting is the prototype for all subsequent images of Our Lady of Light made in New Mexico.
1717	Construction of the fourth and final mission church at Pecos completed. In this church hung an oil painting on canvas of the pueblo's patron, Our Lady of the Angels of Porciúncula, by noted Mexican artist Juan Correa (working 1675–1739). The painting now hangs in the village church in Pecos.

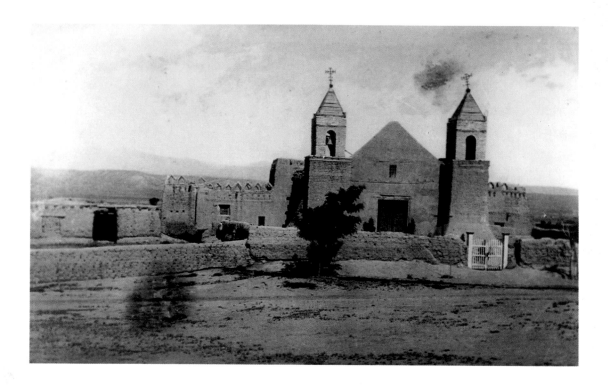

The church at Santa Cruz, built between 1733 and 1748, is of a type typical of churches built in many of the Hispanic settlements in New Mexico in the period. These churches were cruciform in plan and based on the 18th-century baroque churches of Mexico. Photo by William H. Jackson, 1881, Museum of New Mexico Photo Archives. At right, altar screen at Santa Cruz, painted in the style of Rafael Aragón (ca. 1796–1862). The 18th-century Mexican images of saints suggest that the reredos was constructed in that century, probably soon after the church was completed. Photo by Jack Parsons.

1729 Nicolás Gabriel Ortega born, to become the first known weaver in the Ortega family of Chimayó.

1733 Construction of the church of Santa Cruz begins. Completed in 1748, its main altar (undated) contains eighteenth-century canvases from Mexico with images of the Holy Family with Ann and Joachim, St. Rosalia of Palermo, St. Theresa of Avila, St. Joseph, St. Francis Xavier, and St. Barbara. Two additional paintings of the period hang on the walls and are of St. Jerome and St. Cajetan (Vedder 1983).

1737 Altar of the Kings completed in the cathedral in Mexico City. This altarpiece, by Jerónimo de Balbás, introduces the baroque *estípite* style to Mexico.

1747 Mexican friar and *santero* Andrés García is stationed in New Mexico missionary system.

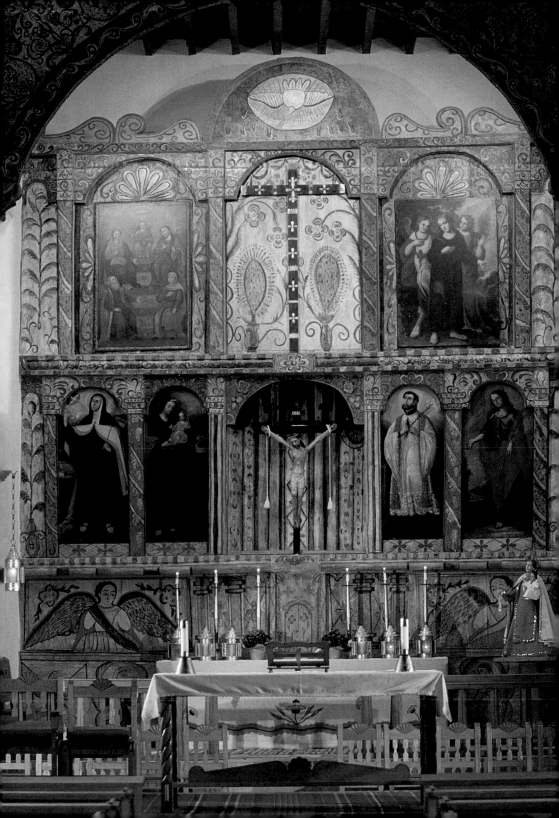

Santa Inez / St. Agnes
Truchas Master, attributed to Pedro
 Antonio Fresquis (1749–1831),
 New Mexico, 1780–1820s.
Gesso and water-soluble paint on wood,
 13⅝ × 10¼ in., SCAS

The Truchas master, named for the altar
screens he painted at the church of Nues-
tra Señora del Rosario in Truchas, New
Mexico, has been identified as the santero
Pedro Antonio Fresquis. Three known
panels by this artist are dated 1809,
1821, and 1827 (Boyd 1974; Gavin et
al., 1990). Fresquis's work is characterized
by retablos with sketchily drawn figures
often set in ornate backgrounds filled with
abstracted floral elements, scrollwork, and
hatched lines. A technique known as
sgraffito, where lines are scratched into the
wet painted surface, is also indicative of
his work. The few bultos attributed to the
Truchas master portray the same narrow
faces with almond-shaped eyes shown
here.

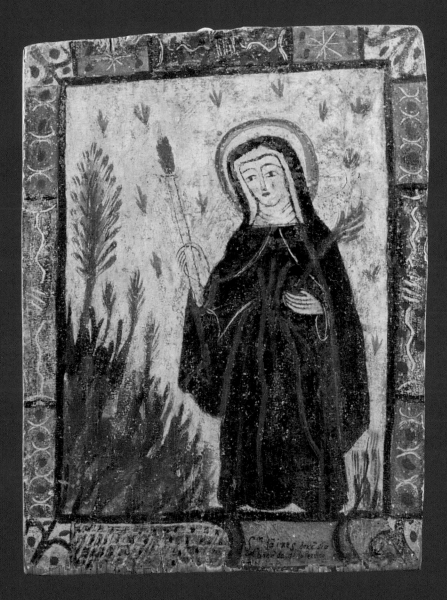

1749 *Santero* Pedro Antonio Fresquis (also called the Truchas Master) born. Baptized at Santa Cruz, he has three dated works, from 1809 and 1827.

1750 Beginning of the *santero* period in New Mexican folk art.

1754 Bernardo Miera y Pacheco arrives in Santa Fe and remains until his death in 1785, when he is buried at La Castrense, a military chapel on Santa Fe's plaza. He makes his living as a captain in the military, a cartographer, and a *santero*.

1760 Bishop Tamarón of Durango, Mexico, visits New Mexico. Licenses are granted to build the churches of San José de Gracia in Trampas, Nuestra Señora del Rosario in Truchas, and La Castrense in Santa Fe.

1761 Stone altar screen completed at La Castrense. This altar screen was probably carved by Capt. Bernardo Miera y Pacheco and now adorns the church of Cristo Rey on Canyon Road in Santa Fe (Carrillo and Mirabal; Pierce and Weigle). The first dated work by a *santero* living in New Mexico, this includes images of God the Father, Our Lady of Valvanera, St. Joseph, St. James, St. John Nepomuk, St. Ignatius Loyola, Our Lady of Light, and St. Francis Solano (von Wuthenau 1935). This is the earliest known example of the baroque *estípite* in New Mexico.

1776 Fray Francisco Atanasio Domínguez's official ecclesiastic visit to the missions of New Mexico. He records the first comprehensive inventory and description of the churches and their furnishings; see *The Missions of New Mexico, 1776* (Domínguez 1956).

Church of San José de Gracia completed at Trampas, with carpentry by Nicolás de Apodaca (eighteenth century) and Juan Manuel Romero (late nineteenth century).

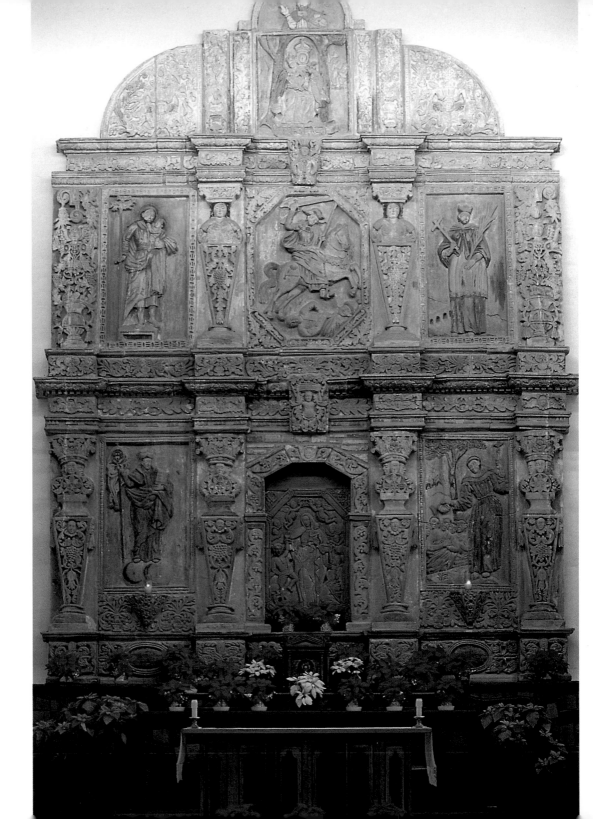

1783 Date of altar screen in the Santuario de Guadalupe, Santa Fe, painted by Mexican artist José de Alcíbar. The screen depicts scenes from the apparition of Our Lady of Guadalupe as well as the Holy Trinity and the Sacred Heart.

1789 Date inscribed on signed nativity cradle by Lorenzo Ortega. This is one of the earliest dated and signed pieces of woodwork from New Mexico (Boyd 1974, see MOIFA accession records; Cash 1990).

n.d. Valdez-family woodcarvers living in Velarde area.

1790 Date that the Laguna *santero* may have arrived in New Mexico. He completes various commissions before returning to Mexico in 1808.

1795 Date of nave altar screen in the church of Santa Cruz, attributed to the Laguna *santero*. This is the oldest dated wooden altar screen in New Mexico.

1796 *Santero* José Rafael Aragón born in Santa Fe.

1798 Date of altar screen in chapel of San Miguel, Santa Fe. This is the first appearance of Solomonic columns in New Mexican artwork. The architecture of the screen is attributed to the Laguna *santero*. Eighteenth-century oil paintings from colonial Mexico include St. Louis, St. Francis, Christ in a niche, and St. Michael by Bernardo Miera y Pacheco; the latter was probably painted between 1754 and 1759 but was hung on a church wall until the altar screen was completed (Boyd 1974; Cornelius 1983).

1802 Rafael Luna of Taos born. He is the first recorded filigree jeweler in the Luna family five-generation tradition (Espinosa 1970).

◄ *Altar screen originally at La Castrense in Santa Fe. Photo by Jack Parsons.*

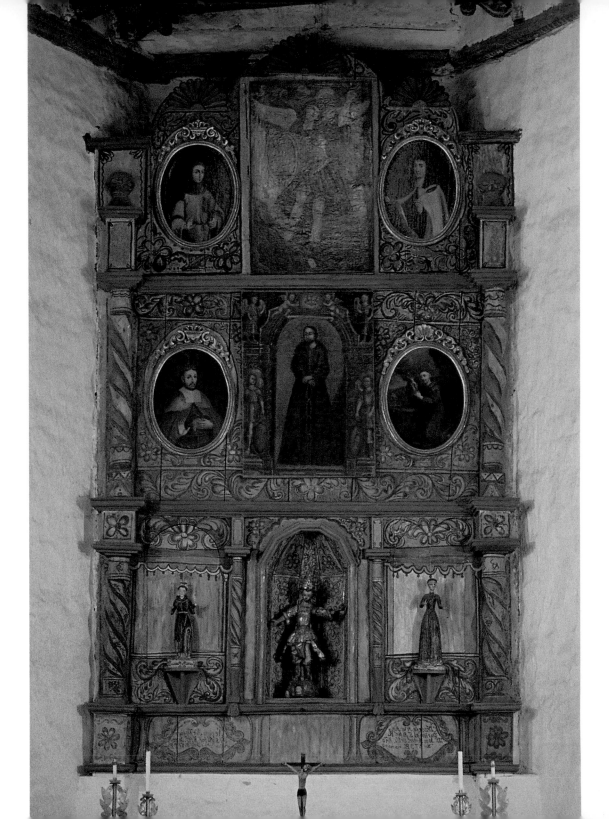

| 1807 | The Bazán brothers, master weavers, arrive in Santa Fe from Mexico to improve the technical skills of New Mexican weavers. |

| 1821 | Mexico declares independence from Spain, claiming New Mexico as its province. While this marks the actual end of the colonial period, colonial art forms and traditions continue in New Mexico. Restrictions on foreign commerce, strictly controlled under Spanish rule, are lifted. The Santa Fe Trail is officially opened for the transport of goods into Santa Fe from across the United States. |

| 1823 | José Concepción Trujillo born. He is the first identified weaver in the Trujillo family of Chimayó (Lucero 1986). |

| 1831 | *Santero* Pedro Antonio Fresquis, the Truchas Master, dies and is buried at the Santuario de Chimayó. |

Master weavers Isidoro and Francisquita Ortega Trujillo, Chimayó, New Mexico, ca. 1940. Mercedes Trujillo Collection.

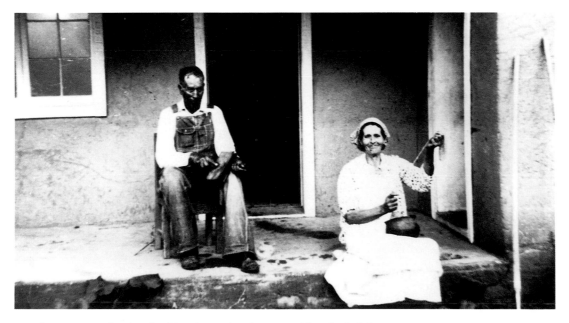

◀ *Altar screen at the church of San Miguel in Santa Fe. Photo by Jack Parsons.*

1835 *Santero* Juan Miguel Herrera born.

1842 Tinsmith, *santero*, and musician Higinio V. Gonzales born. He dies around 1922.

1844 Tinsmith José María Apodaca born. He dies in 1924.

1846 Americans, led by Brig. Gen. Stephen Watts Kearny, occupy Santa Fe and set up a provisional territorial government. This marks the beginning of the mass importation of military supplies in tin containers that provides material for New Mexican tinsmiths.

1847 Taos Rebellion. Gov. Charles Bent assassinated, and New Mexico put under military government.

1848 Treaty of Guadalupe Hidalgo ends the Mexican War and establishes the boundaries of New Mexico, which exclude southern New Mexico but include southern Colorado and much of present-day Arizona.

1850 Territory of New Mexico established by the U.S. Congress, and present Texas–New Mexico boundary established (Texas had been claiming the area west to the Rio Grande).

1853 Gadsden Purchase. The United States acquires southern New Mexico (Mesilla Valley) and southern Arizona from Mexico.

1858 *Santero* José Benito Ortega born. His last major work is completed in 1907. Dies in 1941.

1860 *Santero* José de Gracia Gonzales, a native of Chihuahua, arrives in New Mexico. He creates and restores altar screens and devotional images throughout the churches of northern New Mexico into the late 1870s. Apparently he made plaster *bultos* as well (Wroth 1991).

1862 *Santero* José Rafael Aragón dies in Córdova, is buried at St. Anthony de Padua Church in Córdova. His remains are later moved to the chapel of Our Lady of Carmel in the church of Santa Cruz de la Cañada.

1863 Present New Mexico–Arizona boundary established.

1868 *Santero* José Dolores López born. He dies in 1937.

1878 The Atchison, Topeka and Santa Fe (AT&SF) railroad crosses the Raton Pass into New Mexico, reaching Las

Santero *José Dolores López (1868–1937)*
with his bulto *of the Blessed Virgin Mary.*
Photo by T. Harmon Parkhurst, ca. 1935,
Museum of New Mexico Photo Archives.

· 15 ·

Cruz / Cross
Río Abajo Workshop, New Mexico,
ca. 1870–80.
Tin, 25¼×23¼ in., SAR

Vegas, its first destination in New Mexico, in 1879. The availability of mass-produced products and religious images into the territory is thus greatly increased.

1905 *Santero* Juan Miguel Herrera dies.

1912 New Mexico becomes the forty-seventh state of the Union.

1925 Spanish Colonial Arts Society (SCAS) founded in Santa Fe by Mary Austin and Frank Applegate to help preserve and foster traditional Spanish colonial arts in New Mexico.

1926–34 Annual exhibition and sale of Spanish crafts at the Spanish Market in Santa Fe, sponsored by SCAS.

1934 Mary Austin dies. SCAS activities enter a period of decline.

1952 E. Boyd, curator of Spanish colonial arts at the Museum of New Mexico in Santa Fe, revives the arts society.

1965 SCAS-sponsored Spanish Market reactivated.

1994 The forty-third annual traditional Spanish Market is held in Santa Fe.

Nuestra Señora del Refugio / *Our Lady of Refuge of*
 Sinners
Anita Romero Jones (b. 1930) and Donna Wright de
 Romero (b. 1953), Santa Fe, New Mexico, 1993.
Tin, glass, wool embroidery on linen, 21 × 14¼ in.,
 SCAS. *Photo by Jack Parsons.*

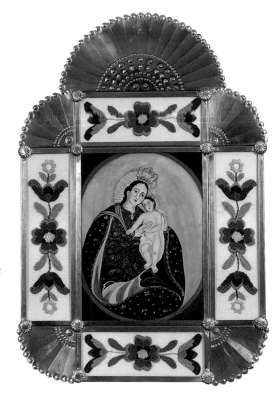

Anita Romero Jones and her daughter, Donna Wright de Ro-
mero, are among four generations of artists in the Romero
family. Jones's parents, Emilio and Senaida Romero, are master
tinsmiths and National Heritage Fellows. Senaida Romero was
among the first to incorporate colcha *embroidery into the tin*
pieces she and her husband created, and she taught the colcha
stitch to her granddaughter, Donna. In this piece, Jones and
Wright have added another dimension by combining their talents
as tinsmith, santera, and colcha *embroiderer, resulting in an in-*
novative multimedia expression of a traditional image.

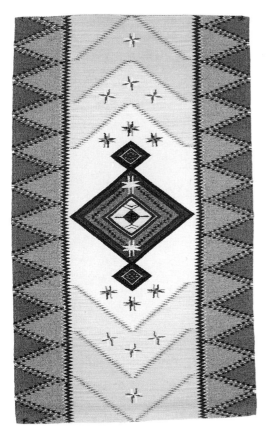

Gemini Blues (Poetry Series)
Teresa Archuleta-Sagel (b. 1952), Española,
 New Mexico, 1992.
Wool, vegetal dyes, 55 × 32½ in., SCAS

Historic documents reveal little about the participation of
Hispanic women in the arts. Recently, however, researchers
have pointed out the almost certain participation of
women in the economic life of colonial families and com-
munities, including artistic production. Weaving was one
of the family enterprises that crossed both gender and age
barriers in virtually every step of the process. Today, many
Hispanic women are among the acknowledged masters of
their craft. Teresa Archuleta-Sagel, who started weaving in
1972, has extensively researched the traditional designs,
dyes, and techniques of New Mexico's weavers. In Gemini
Blues *she has drawn upon traditional elements, such as*
the Vallero star and the Saltillo serape, to form a composi-
tion that spans the generations. (Poem not shown.)

TRADITIONAL ARTS OF SPANISH NEW MEXICO

The church of San José de Gracia in Las Trampas, built between 1760 and 1776, illustrates how the structure, in both placement and stature, was the focal point of the community. Photo by Jesse L. Nusbaum, ca. 1912, Museum of New Mexico Photo Archives.

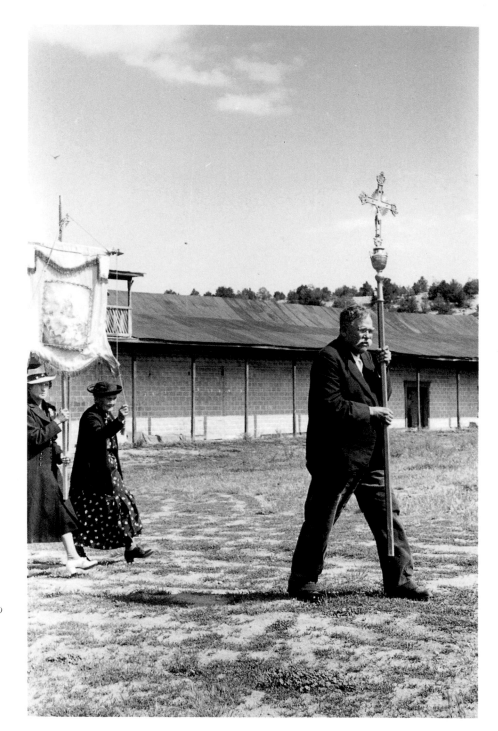

Religious procession in New Mexico village of Peñasco in the 1940s. Shown are Facundo Medina, Mrs. Margarita Martínez, and Mrs. Juanita Frésquez. Photo by Russell Lee, courtesy U.S. Library of Congress.

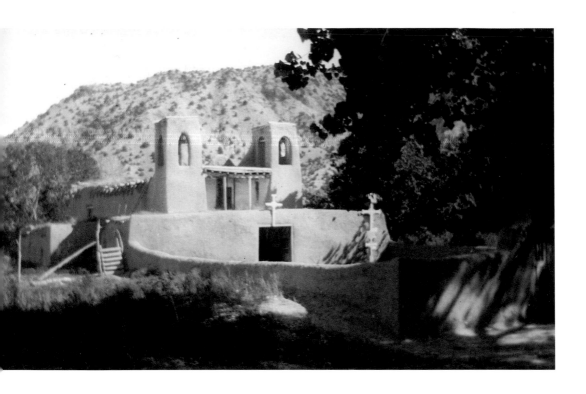

Immigrants leaving their homeland take their culture with them, but they lose regular daily contact with that culture at its core, where it continues to change. These migrant culture-bearers thus often become the preservers of traditions no longer practiced in their culture's hearth; immigrants abroad sometimes save what was lost at home.[1]

The santuario *in Chimayó was completed in 1816. Its architecture reflects that of many of the single-nave mission churches built in the Rio Grande pueblos in the 18th century. Photo by Kenneth Chapman, 1917, Museum of New Mexico Photo Archives.*

Three hundred ninety-five years ago, the first Spanish settlement was established on the northern frontier of New Spain, in what is today New Mexico. Thus began a long, two-and-one-half-century colonial period (1598–1821), followed by a brief Mexican period (1821–46) and sixty-six years as a U.S. territory (1846–1912). New Mexico became the forty-seventh state of the Union in 1912. Much of the history of these four centuries is contained in elusive documents dispersed throughout the

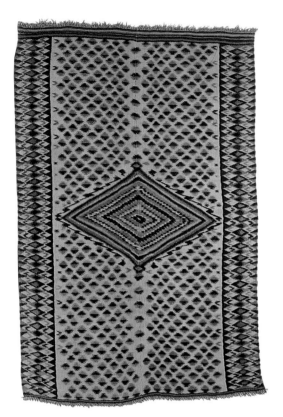

Frazada Río Grande / Rio Grande Blanket
New Mexico, 1850s–60s.
Wool, vegetal dyes, 76¾ × 50¾ in., SCAS

The design of this blanket, known as a Rio Grande
saltillo, is based directly on the Mexican Saltillo se-
rape, whose design is characterized by three zones as
seen here: a frame or border around the outside
edges; a field of different and generally simpler de-
signs inside; and a large concentric diamond in the
center.

United States, Mexico, and Spain, but another, equally important part
of this history remains evident here in New Mexico, in its folk art.

Thousands of miles from their home in Spain or Mexico, the colo-
nists clung to things and ways familiar to them. Through families and
across generations, traditions and art forms were passed on orally, by
stories, songs, and *dichos* (sayings), and by example, through method,
design, and construction. Over the years, these traditions were affected
by both exchange and intermarriage with Native Americans, by the
long distances from Spanish economic and artistic centers such as Mex-
ico City, and by individual needs for embellishment and innovation.
What developed was, and continues to be, a culture rooted in Spain but
distinctly and uniquely Hispanic New Mexican.

The material and artistic expression of this culture is known as New

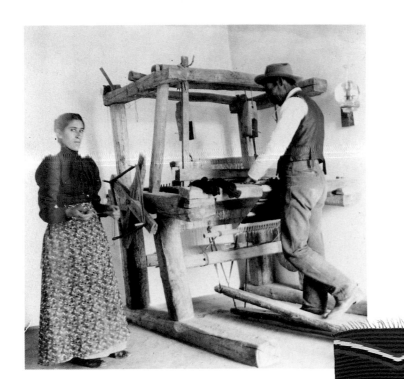

Mrs. Esquipula Martínez prepares a skein of wool while Mr. Martínez weaves at his loom. Chimayó, New Mexico, ca. 1910. Prudence Clark Collection at the Menaul Historical Library of the Southwest.

Frazada Tipo Chimayó / *Chimayó Blanket*
New Mexico, ca. 1925.
Wool, cotton, aniline dyes, 73×46 in., IFAF

Created specifically for the tourist market, Chimayó weavings became popular in the late 1800s. Sizes, designs, and materials were all standardized to meet tourist needs and Hispanic and Native American designs were combined to satisfy the tourists' ideas of Southwest art. This Chimayó blanket combines design elements associated with Saltillo, Chimayó, and Pueblo Indian weavings. The blue ground with black stripes is known as the Pueblo "Moki" pattern while the diamond or lozenge motif derives from the Mexican Saltillo serapes (Lucero 1987).

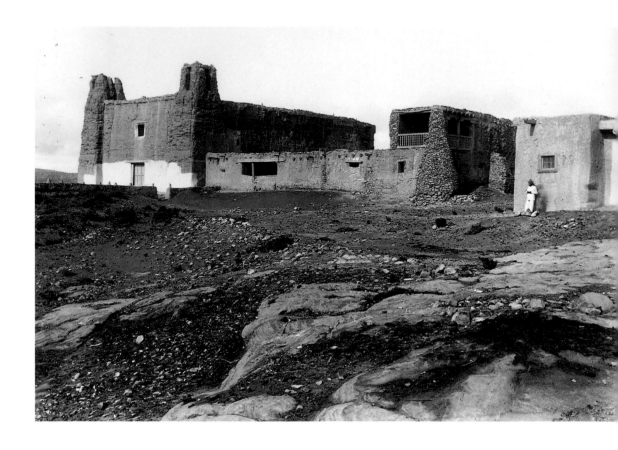

The first mission churches built by the Spanish in New Mexico, such as San Esteban del Rey at Acoma Pueblo, built in the early 17th century, were large, often single-nave structures based on the 16th-century monumental stone mission churches of Mexico. Photo by the Rev. John C. Gullette, 1900, Museum of New Mexico Photo Archives.

Mexican Hispanic folk art, whose distinguishing characteristics—ingenuity and adaptability, straightforward design and execution combined with the expressiveness of raw materials, and the merging of a community aesthetic with the idiosyncrasies of the artist's hand—began to emerge in the late 1700s. In the two centuries previous, much of the non-Indian art in New Mexico was imported from Mexico or was heavily based on Mexican art. After 1879–80, with the arrival of the railroad, folk art in New Mexico was again heavily impacted by items flowing into the area from outside. But the years between about 1750 and 1880 saw New Mexico's Hispanic folk art, both religious and secular, in its greatest period of unique expression.

Cruz / Cross
New Mexico, late 18th–early 19th
century
Wood, straw, 15¾ × 9¼ in., IFAF

New Mexico was established as a Spanish colony in 1598, when Don Juan de Oñate led some two hundred colonists to the northern Rio Grande and founded San Juan de los Caballeros. Eight Franciscan friars accompanied the party. The Franciscan Order had earlier sent the first missionaries to New Spain and had been responsible for the conversion of the Indians throughout most of north-central Mexico for the previous seventy-five years. In their first forty years in New Mexico, the friars erected between thirty and fifty churches.[2] While many of these were small, isolated structures designed to meet liturgical needs as quickly as possible, some, such as those at Gran Quivira, Quarai, Abó, Acoma, Pecos, and Jémez, were large, complex mission establishments with attached *conventos* (friaries) and outbuildings based on the sixteenth- and early-seventeenth-century monumental stone mission churches of Mexico.

Unfortunately, because virtually everything Hispanic in origin was

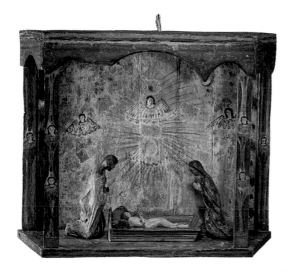

El Nacimiento / The Nativity
New Mexico, late 18th century.
Gesso relief, gesso and water-soluble
paint on wood, 23 × 28½ × 7⅝ in.,
HSNM

destroyed in the twelve years following the Pueblo Revolt of 1680, little remains from the first century of Spanish presence in New Mexico. Information about the material culture of the early colonial period is found primarily in church inventories and archaeological remains.[3] Inventories from the mission supply caravans that brought goods and supplies to the friars from Mexico every three years included artwork for use in the churches. The 1612 shipment included tabernacles, carved and gilded crosses, carved and painted images of Christ, and oil paintings, presumably of saints.[4] In the 1631 contract, items to be sent for the establishment of a new church included an enameled silver chalice with a gilded paten and cup, an oil painting of a saint with a gilded frame, a tin plate with *vinajeras* (cruets), a crucifix, and, for every five friars, two carved images of Christ.[5] A 1672 inventory of church furnishings listed the following items in the church of San Esteban at Acoma Pueblo:

> Inside there is a gilded *retablo* [altar screen] in three sections with images in the round and paintings, the handiwork of the best artists of Mexico, and two side altars corresponding to the main altar, also made in Mexico. . . . In addition, a beautiful Crucifix, and more canvases, all the handiwork of great artists and brought from Mexico. Also, a very fine silver gilt tabernacle.[6]

While many objects were imported from Mexico, there is also evidence of local artistic production by the early seventeenth century. Paintings of religious subjects on tanned animal hides are some of the earliest documented images made in the Spanish colonial era in New Mexico. The Franciscan friars, who usually had a number of missions to oversee, needed easily transportable imagery for use in teaching the catechism; paintings on hide were the perfect solution. They were not gessoed, so paint soaked into the hide and would not flake off easily; they were economical, as the material, unlike canvas, was locally available and tanned by the local Indian population; and they could be rolled for easy transport. Both textiles and hide paintings were exported to Mexico from New Mexico as early as the 1630s.[7]

La Crucifixión / *The Crucifixion*
"Franciscan F" Style, New Mexico,
 early 18th century.
Water-soluble paint on hide, 75¾ × 53 in., SCAS

Painted hides were produced in New Mexico throughout most of the
1600s and 1700s; for much of this time they were a major export
item to Mexico. Then, in 1818, the ecclesiastical inspector from
Durango, Mexico, ordered their removal from many of the churches
in New Mexico, stating that they were "improper" as adornment for
the altars. This stance was reiterated by subsequent inspectors and
few, if any, paintings on hide were produced after the 1840s.

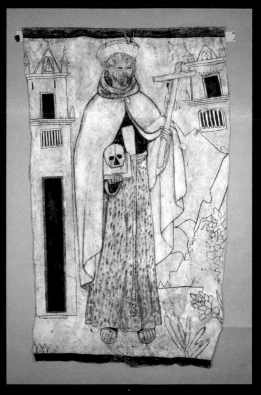

San Francisco de Asís / St. Francis
 of Assisi
"Franciscan F" Style, New Mexico,
 early 18th century.
Water-soluble paint on hide,
 70¼ × 43 in., IFAF

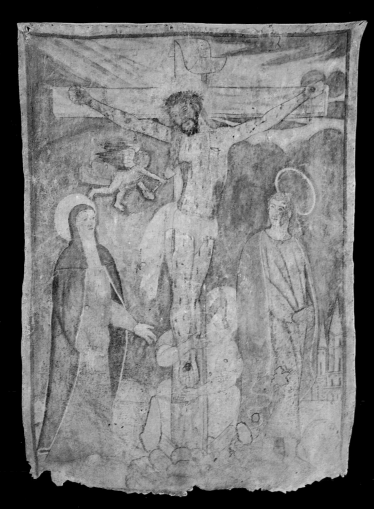

In addition to hide paintings, there is evidence of local woodworking in the first century of Spanish settlement. Fragments of seventeenth-century carved beams, railings, and a single bench have been excavated from various missions. The Indians of Pecos, trained by Hispanic artisans, were well regarded as carpenters beginning in the early seventeenth century.[8] At least one Flemish silversmith was living in Santa Fe by 1639.[9] Indians as image-makers are mentioned several times in documents and in church inventories, and Governor Luis de Rosas had a workshop of Indian weavers producing textiles for export in the late 1630s.[10] European techniques were transmitted to the local people through loosely organized artisanships as part of the general Spanish missionary effort, as well as through government and civilian enterprises, in frontier New Spain.

A new era of skilled tradesmanship began with the Spanish resettlement of New Mexico after the Pueblo Revolt, led by the reconquest expedition of Don Diego de Vargas in 1692–93. For the following century, new Spanish settlements were established along the Rio Grande and its tributaries. Towns were founded and churches built in the communities of Santa Cruz, Albuquerque, Tomé, Abiquiú, Truchas, and many more. These parish churches, although still administered by the Franciscan Order, were paid for in large part by the communities and on occasion by wealthy donors.[11] Their design followed that of contemporary eighteenth-century baroque parish churches in Mexico, which featured the Latin cross plan with the main entry at the end between two towers.[12] The dome that typically sprang from the crossing and provided both drama and illumination was replaced, in New Mexican design, with the transverse clerestory window located at the front of the crossing that directed light toward the altar.[13]

Decoration of these churches was usually restricted to interior furnishings consisting of the main and side altar *reredos* (screens), as well as smaller individual works and the architectural and decorative woodwork. Although much of this work was still imported from Mexico, there is evidence that strong local traditions were emerging among the Hispanic craftsmen. Hide paintings and textiles were once again being

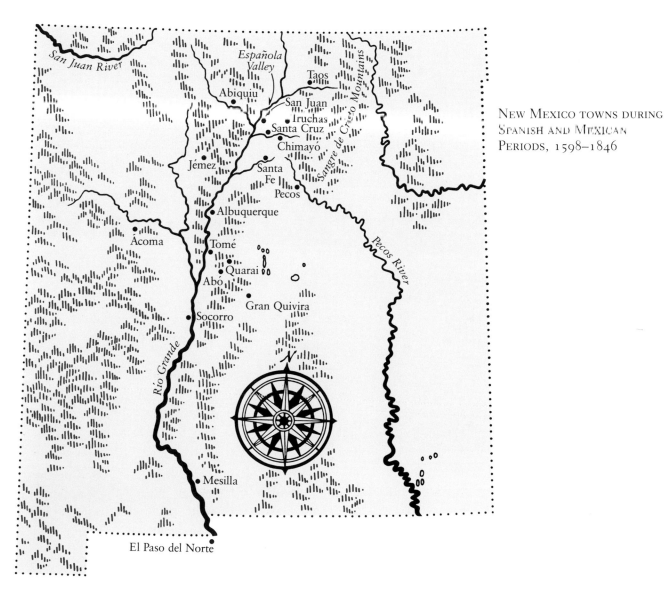

NEW MEXICO TOWNS DURING
SPANISH AND MEXICAN
PERIODS, 1598–1846

produced by Hispanic artists[14]; Bernardino Sena set up a blacksmith
shop in Santa Fe in 1693 that was to serve the city for generations[15];
Diego de Velasco was documented as a master carpenter in Santa Fe in
1710; and by the end of the century there were at least forty men in New
Mexico claiming their profession as carpenter.[16]

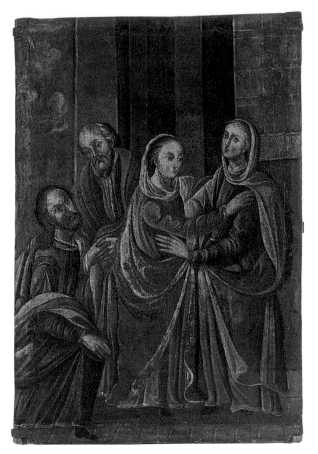

La Visita / The Visitation
New Mexico or Mexico, late 18th century.
Oil on canvas, 32¼×21¾ in., MNM

A number of works on canvas are among the few surviving examples of artwork, aside from the hide paintings, that probably adorned the churches of New Mexico in the 18th century. The style of the painting as well as the narrative subject matter suggest a familiarity with and a use of Mexican Baroque prototypes. The images are rendered in perspective, albeit with some distortion, with naturalistic treatment in the folds and highlighting of garments and motion in the figures. Such images may have been sent up from Mexico or may have been painted locally.

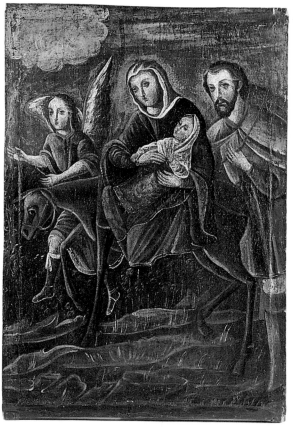

La Huida a Egipto / The Flight
into Egypt
New Mexico or Mexico, late 18th
century.
Oil on canvas, 31¾×22¼ in.,
MNM

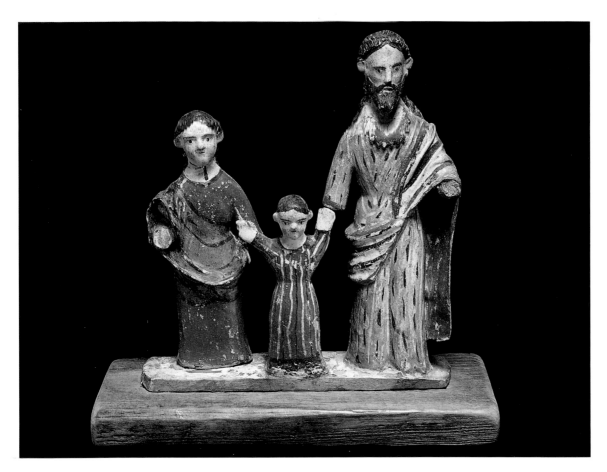

In 1776, Fray Francisco Atanasio Domínguez, an ecclesiastical inspector sent from the headquarters of the Franciscan Province of the Holy Gospel in Mexico City, made a complete inventory of the churches he visited in New Mexico. He noted numerous religious images (*santos*) made by local hands and identified Don Bernardo Miera y Pacheco and Fray Andrés García as image-makers (*santeros*). His remarks about their work, however, were somewhat disparaging:

> [At the church of Santa Cruz de la Cañada] there is a large image in the round of Our Lady of the Rosary; . . . Father García made the image, and perhaps for the shame of her being so badly made they left the varnish on her face very red. [17]

La Sagrada Familia / The Holy
 Family
New Mexico, late 18th century.
Gesso and water-soluble paint on
 wood, 9½ × 9⁵⁄₁₆ × 3¾ in., IFAF

This bulto of the Holy Family is
done in the style sometimes attributed to Fray Andrés García. Fray
Andrés, who was born in Puebla,
Mexico, was sent to the New Mexico missions in 1747.

San José / St. Joseph
Attributed to Bernardo Miera y
 Pacheco (d. 1785), New Mexico,
 1754–85.
Gesso and oil on wood, H: 42 in.,
 ASF

Don Bernardo Miera y Pacheco,
born in Burgos, Spain, moved to
New Mexico in 1754, where he ap-
parently filled commissions for a
number of churches. Two sculptures
of archangels from Nuestra Señora
de Guadalupe at Zuñi, carved door
panels from Santo Domingo, the
carved stone altar screen from the
military chapel, La Castrense, on
the Santa Fe plaza, and a similar
statue of St. Joseph at San José de
Gracia in Trampas have all been
attributed to him (Carrillo and
Mirabal; Pierce and Weigle). His
painted images show the somber
colors and monumentality of the
late Spanish baroque and 18th-
century Mexican baroque painters
such as the Juárez brothers and An-
tonio de Torres. Unlike most of the
later 19th-century santeros who
used vegetal pigments, Miera y
Pacheco worked in oils.

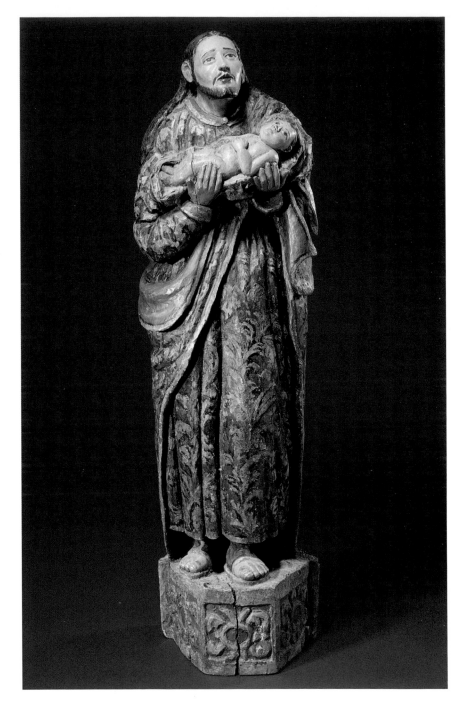

Bernardo Miera y Pacheco was, in addition to a craftsman, both a military officer and a cartographer. It is likely that other artisans of the period were forced to supplement their incomes with occupations outside their trades. The situation soon changed. From the late 1700s to the mid-1800s there seems to have been a surge in the production of locally made items to meet the needs of an expanding New Mexican population. One's skill as a craftsman apparently was no longer considered a sideline as it had been before this period and would again be later when commercially manufactured goods began to flow into the colony. A system of *talleres*, or workshops, seems to have developed where master craftsmen oversaw work and trained apprentices. In the tradition of European guilds, design and production became a family enterprise.[18] Most of what is known about Spanish colonial arts in New Mexico and the bulk of extant examples come from this period of production that extends from the late Spanish colonial era and into the Mexican and through the territorial periods. Accounts from early Anglo traders in the area and later interviews with individuals recalling their youth and the old ways help to broaden our picture of nineteenth-century New Mexico.

By the late 1800s, the *santero*, like any master artist, had gained considerable standing in his community, as reflected in the recollection of Cresenciana Atencio, recorded by the WPA in 1940:

> The *Resador* [*rezador*, one who leads congregation in prayer] was a highly respected Person, and no one cared to offend him. For they never knew when he might be needed.
>
> The *Resador* usually was some man Who's father had been a *Resador* before him, and from whom he had learned *Los Resos*, and *Alabados*, "Prayers and humns [hymns]."
>
> Some of these old men in their youth, had been placed with the *Padre*, of their Village church by their parents, to learn the ways of good Christians. These boys worked for, and waited on the Priest, and went with him on his journeys to the different *Placitas*, assisting at Mass as Alter boys. In return for this, The *Padre* taught them their prayers, and Catechism, and some times to read and write. . . .

Angel de la Guardia / *Guardian Angel*
José Aragón, New Mexico, 1825. Gesso and water-soluble paint on wood, 22 × 11¼ in., cw

The inscription on this retablo states that it was made in the escultería, or workshop, of José Aragón in 1825. This is one of the panels that provides the evidence that there were workshops operating in New Mexico in the late 18th and early 19th centuries.

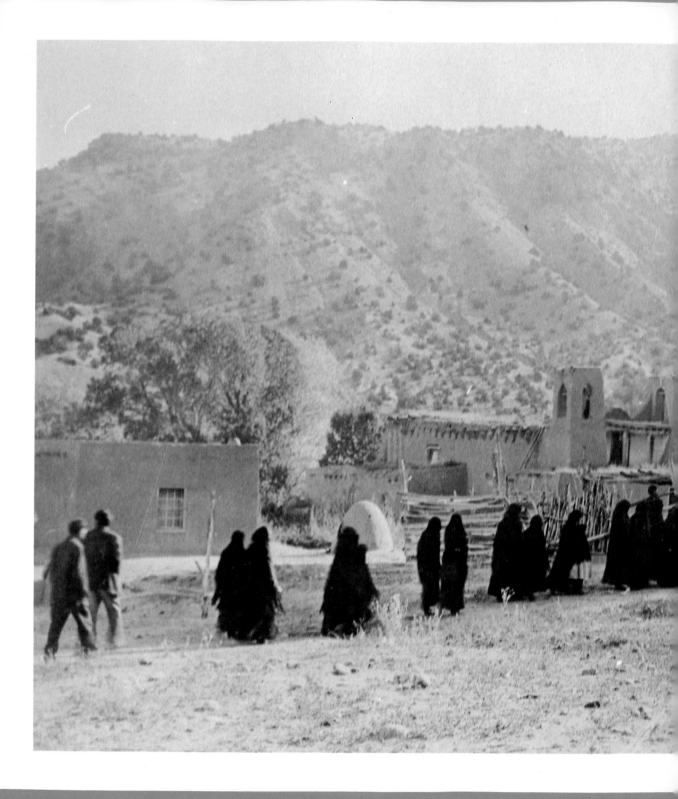

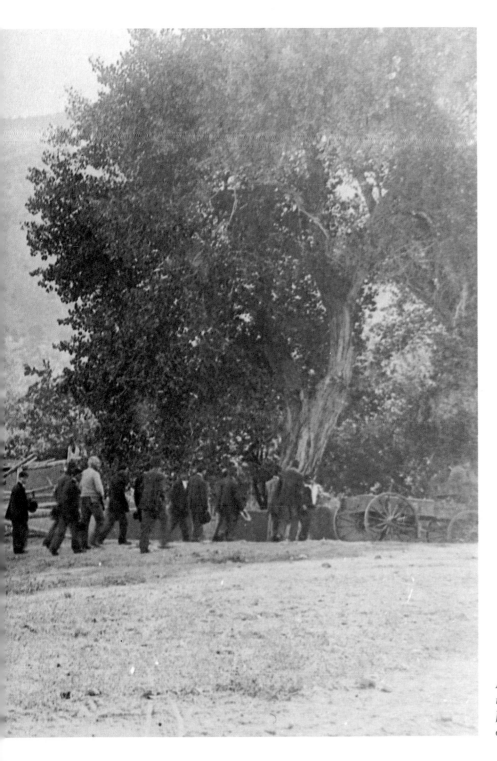

A religious procession approaching the santuario *at Chimayó. Photo by Jesse L. Nusbaum, 1910, Museum of New Mexico Photo Archives.*

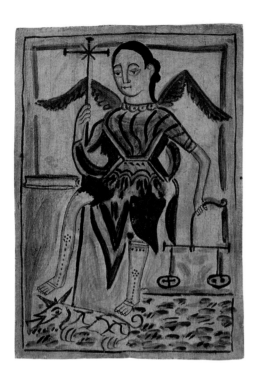

San Miguel, Arcángel / St. Michael,
 Archangel
Molleno, New Mexico, 1815–45.
Gesso and water-soluble paint on
 wood, 11⅛ × 7⅝ in., SCAS

The *Resador* often was the *Santero* also. The poor people could
not afford to pay the prices that were asked for sacred pictures
brought from Mexico. So had them made at home by the *San-
tero,* or *Resador.* Who after hewing and smoothing pine boards
of different lenghts [*sic*], painted on them the pictures of Mary,
and the Saints to the best of this knowledge. The people bought
or bartered for them. Then waited for the Padre's next visite to
their church,—which was usually once a month.—and have
them blessed.[19]

Despite the respect accorded them, relatively few artists' names have
been recorded from the period of the late 1700s to early 1800s. Pedro
Antonio Fresquis, Molleno, Rafael Aragón, and José Aragón are among
those that history mentions. Other artists remain anonymous but are
referred to by historians according to their styles or some indicative sym-

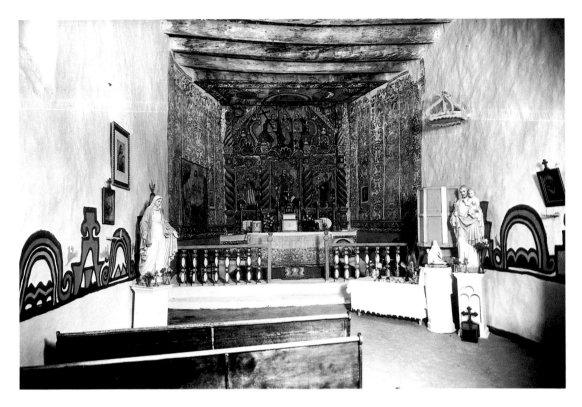

bol: the "Laguna *Santero*" painted the altar screen at the mission church at Laguna Pueblo; the "A. J. *Santero*" was named for the initials "A. J." that appear on one of his panels; the "*Santo Nino Santero*" made numerous images of the Holy Child, and so on. It is evident from some of these works, as well as from variations within the range of one style, that in this period of artisanship workshops based on the guilds that operated in Mexico in the colonial period were operating on a smaller scale in New Mexico:

> The little [*taller*] is a family operation. . . . It is directed by explicit instruction, but what is more important, it is constrained by a reduction in the range of models available for imitation. The result is a more restricted style, which, sturdily compressed and reinforced by blood, can survive on its own without support from the wider community.[20]

The altar screen at the Church of San José at Laguna Pueblo was painted by the anonymous Laguna santero between 1798 and ca. 1808 and is one of the earliest extant painted altar screens in New Mexico. Photo by T. Harmon Parkhurst, ca. 1935, Museum of New Mexico Photo Archives.

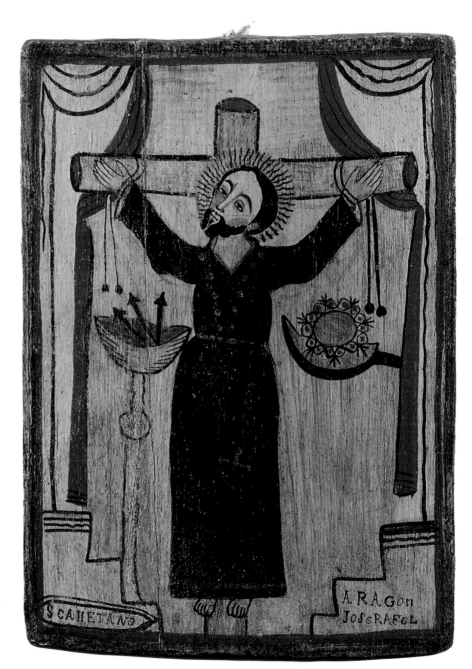

San Calletano / St. Cajetan
Rafael Aragón (ca. 1796–1862),
New Mexico, 1820–62.
Gesso and water-soluble paint on
wood, 10⅞×7⅞ in., SCAS

San Ramón Nonato / St. Raymond
the Unborn
*José Aragón, New Mexico,
1820–35.
Gesso and water-soluble paint on
wood, 9½ × 5½ in.*, SCAS

This interior of the santuario *in Chimayó shows the white-
washed adobe walls, the typical* viga *(beam) ceiling sup-
ported by decorative carved corbels, and the locally made
altars that were in the church by the mid-1800s. The altar
on the left was painted by* santero *José Aragón while the
main altar is attributed to Molleno. The gilt frame around
the central niche was imported from Mexico. Photo by
Jesse L. Nusbaum, ca. 1911, Museum of New Mexico
Photo Archives.*

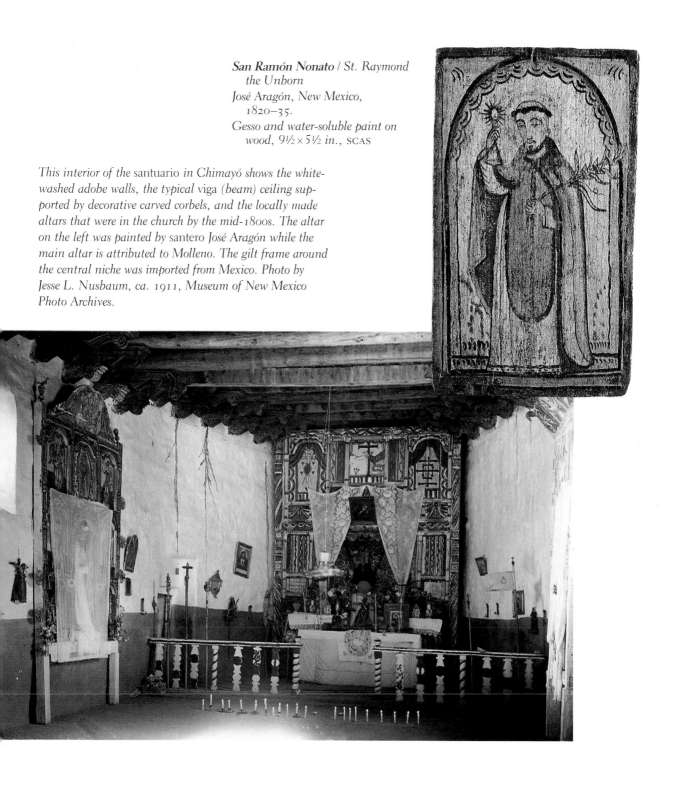

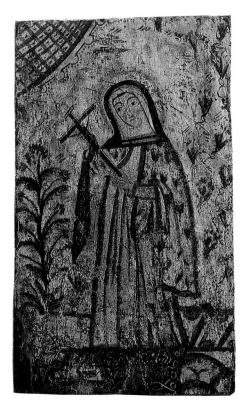

Santa Coleta / *St. Colette*
*Truchas Master, attributed to Pedro
 Antonio Fresquis (1749–1831),
 New Mexico, 1780–1820s.*
*Gesso and water-soluble paint on
 wood, 17³⁄₁₆ × 10¹¹⁄₁₆ in., CW*

*After years in reclusion, St. Colette
(1381–1447) set about to reform
the Poor Claires, the Second Order
of St. Francis. She imposed upon
them absolute poverty and perpet-
ual fast, two of the basic tenets of
the Franciscan Order. She is usu-
ally shown as an abbess, often
barefooted and with a lamb at
her feet.*

Santa Coleta / *St. Colette*
*José María Montes de Oca,
 Mexico, 1788–1820.*
*Engraving on copper plate,
 7½ × 5½ in., SCAS*

*St. Colette was canonized
in 1807. Prints such as this
one, probably made and
widely distributed at the
time of her canonization,
served as models for New
Mexican santeros and help
to identify the images today.*

Although they took stylistic liberties, for imagery New Mexican *san-
teros* confined themselves to traditional Christian iconography. Printed
images were brought to New Mexico by way of illustrated missals and
bibles, individual broadsheets, and devotional cards. Additional sources
for the *santeros* were oil paintings and sculptures brought up from Mex-
ico on the supply caravans to adorn the churches and missions. These
prints and paintings in turn were based upon works by northern Eu-
ropean masters, such as Rubens and Rembrandt, and by Spanish artists
of the sixteenth and seventeenth centuries, such as Montañes, Zur-
burán, and Murillo.[21]

· 40 ·

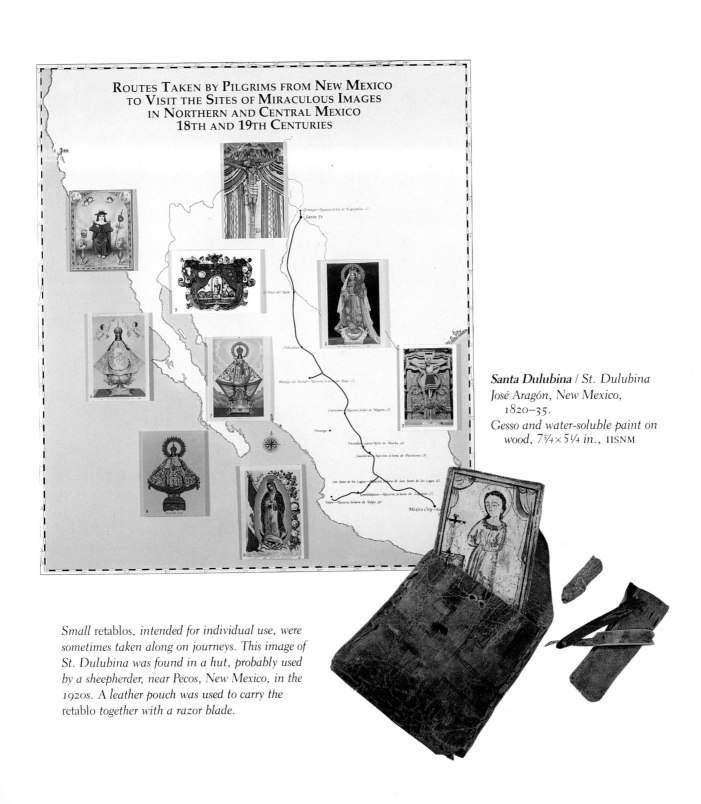

ROUTES TAKEN BY PILGRIMS FROM NEW MEXICO
TO VISIT THE SITES OF MIRACULOUS IMAGES
IN NORTHERN AND CENTRAL MEXICO
18TH AND 19TH CENTURIES

Santa Dulubina / St. Dulubina
José Aragón, New Mexico,
1820–35.
Gesso and water-soluble paint on
wood, 7¾ × 5¼ in., IISNM

Small retablos, *intended for individual use, were*
sometimes taken along on journeys. This image of
St. Dulubina was found in a hut, probably used
by a sheepherder, near Pecos, New Mexico, in the
1920s. A leather pouch was used to carry the
retablo *together with a razor blade.*

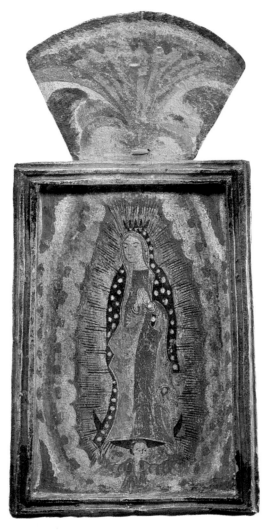

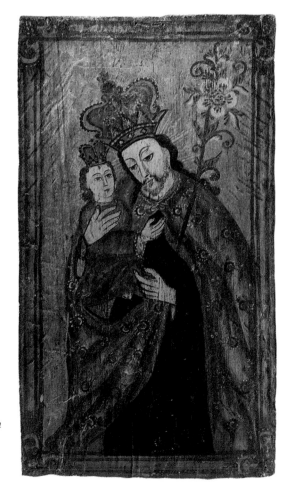

Nuestra Señora de Guadalupe / Our Lady of Guadalupe
A. J. Santero, *New Mexico, 1820s.*
Gesso and water-soluble paint on wood, 25⅝ × 12¾ in.,
FH

The A. J. santero is an anonymous artist referred to by
these initials located in the corner of one retablo. One
dated panel indicates that he was working in the 1820s.
A palette of blues, purples, oranges, and browns distin-
guishes this artist's work from that of others of the period.

San José / St. Joseph
Laguna Santero, New Mexico,
1795–1810.
Gesso and water soluble paint on
wood, 33¾ × 18¾ in., SCAS

Nuestra Señora del Rosario /
Our Lady of the Rosary
Santo Niño Santero, New Mexico,
1830–60.
Gesso, cloth, tin, wood, and water-soluble paint, H: 40½ in., CW

This image is of a type known as a
"hollow skirt." The lower half, or
skirt, of the figure was constructed
from a framework of wooden sticks
over which was laid a cloth dipped
in gesso. When the gesso dried, the
stiff cloth provided a surface suit-
able for painting. The Virgin's
crown is tin and was probably
made locally.

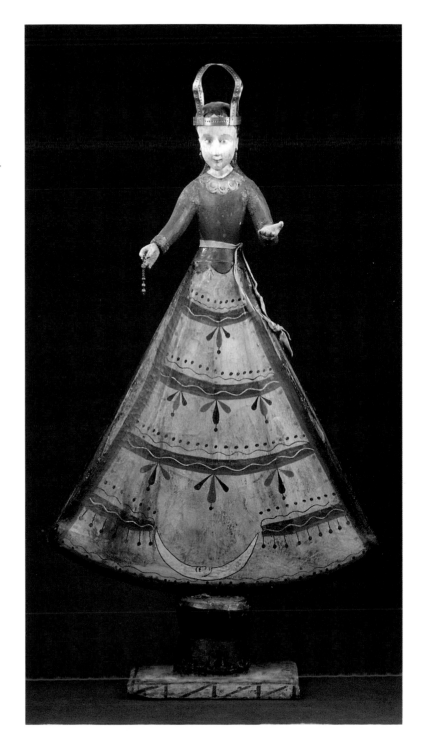

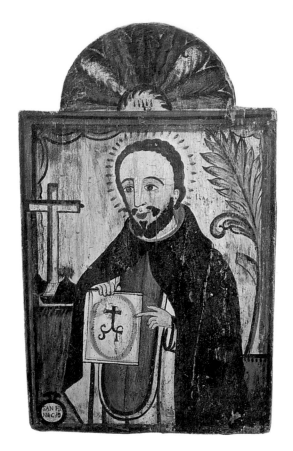

San Ygnacio / *St. Ignatius Loyola*
Arroyo Hondo Painter, New Mexico, 1828–40.
Gesso and water-soluble paint on wood, 25¾ × 15¾ in.,
SAR

The Arroyo Hondo painter was an anonymous santero
known by his major work, the altar screen for the church of
Nuestra Señora de los Dolores in Arroyo Hondo, New
Mexico. (This altar screen is now at the Taylor Museum in
Colorado Springs, Colorado.) Little is known about this
artist, but, based on similarities in style, he is thought to
have been a follower of José Aragón. His usually half-
length portraits set on a plain ground are often surrounded
by a linear border incorporating dots and dashes—thus,
an earlier attribution as the "Dot-Dash" santero.

La Santísima Trinidad / *The Holy Trinity*
Quill Pen Santero, New Mexico, 1830–50.
Gesso and water-soluble paint on wood, 12¾ × 12⅛ in.,
SCAS

The Quill Pen santero was named for delicate lines that
appear to have been rendered with a quill pen or similar
instrument. Characteristics of his style are oval faces, el-
liptical eyes, and intricately drawn details in costumes
and borders. Some of the motifs found on his pieces have
led researchers to suggest that he may have been Native
American (Wroth 1982).

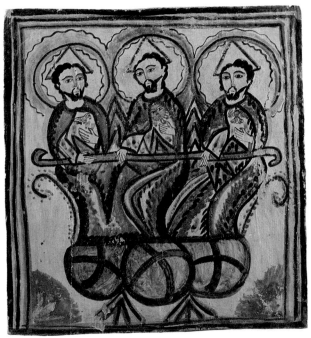

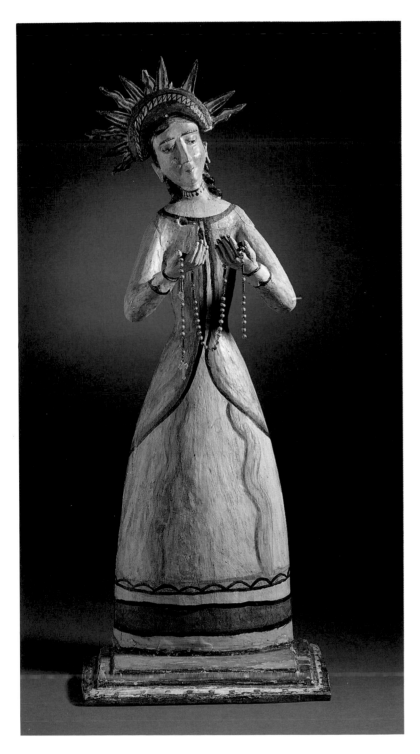

Nuestra Señora de los Dolores / *Our Lady of Sorrows*
Arroyo Hondo Carver, New Mexico, 1830–50.
Gesso and water-soluble paint on wood, H: 26 in., CDC

The anonymous Arroyo Hondo carver is named for the village in which several of his bultos *were found. The style of this carver is characterized by elongated figures with oval faces, half-moon eyes, and long narrow noses and a bright palette of yellows, oranges, reds, blues, and greens. This* bulto *of Our Lady of Sorrows, although holding a rosary, has a hole in her breast where an iconic sword traditionally would have been placed.*

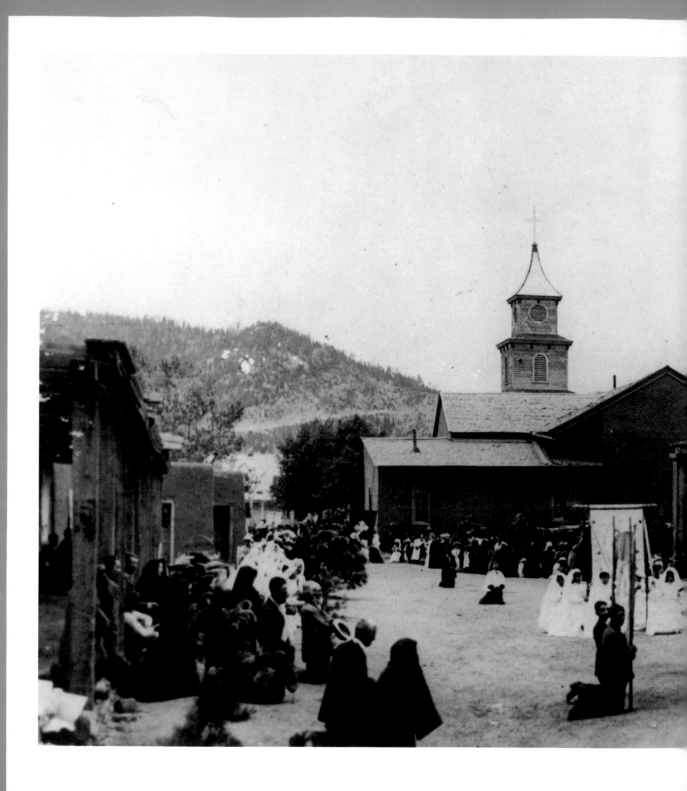

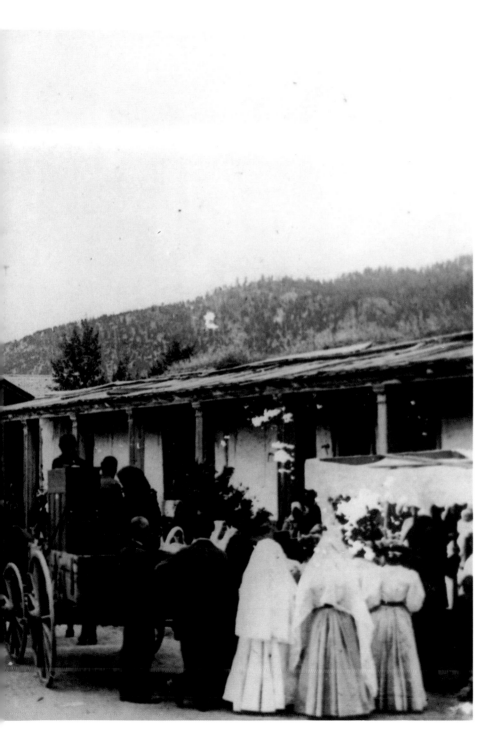

Religious processions are often held on feast days to venerate a particular saint or holy personage. The Feast of Corpus Christi venerates the Blessed Sacrament, here carried in procession through the town of Pecos. Photo ca. 1905, Museum of New Mexico Photo Archives.

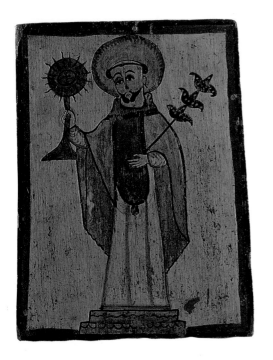

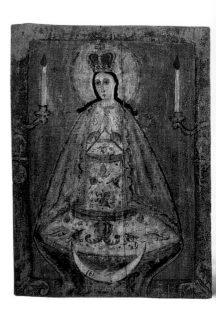

Nuestra Señora de San Juan de los Lagos / *Our Lady of San Juan de los Lagos*
School of the Laguna Santero, New Mexico, early 19th century.
Gesso and water-soluble paint on wood, 20½ × 15 in., IFAF

San Juan de los Lagos, in Jalisco, is a major pilgrimage site in northern Mexico. A small statue, some six inches high, of the Immaculate Conception draws hundreds of thousands annually. It is said that in the 17th century, the image miraculously restored the life of a young girl who had been stabbed with a dagger. Since that time, numerous other miracles have been attributed to the statue (Turner 1990).

San Ramón Nonato / *St. Raymond the Unborn*
Santo Niño Santero, New Mexico, 1830–60.
Gesso and water-soluble paint on wood, 9¼ × 7⅛ in., SAR

San Ramón, who was miraculously born by cesarean section after his mother died in childbirth, is patron saint of pregnant women and infants.

So strong was—and is—the Catholic presence in New Mexico that saints and holy personages were treated virtually as family members. *Bultos* (sculptures usually of cottonwood) were often cared for by community members, who kept them safely and dressed them according to the liturgical calendar. Both *bultos* and *retablos* (paintings on pine panels) were taken in procession, carried to people's homes for use in asking for a saint's aid or intercession, and brought into the fields in times of harvest or drought. In another account by Cresenciana Atencio,

> When a certain Saint had granted some favor, such as making the sich [*sic*] well again, or bringing back Father or husband safe from some long journey, a *velorio*, "Wake," would be given, or held, in honor of the *Santo* who had been appealed to.

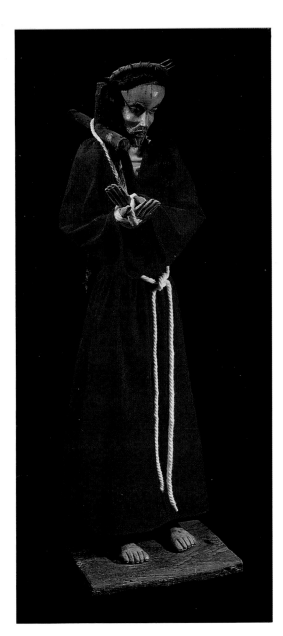

Nuestro Padre Jesús Nazareno / Our Father
 Jesus of Nazareth
*Abiquiu Santero, New Mexico, late 19th
 century.*
Gesso and oil paint on wood, H: 44⅛ in.,
 CDC

San Francisco de Asís / St. Francis of Assisi
New Mexico or Mexico, 19th century.
Cotton, leather, gesso and water-soluble paint on wood,
 H: 22 in., IFAF

*These two images, of Jesus of Nazareth and St. Francis, show
how bultos were typically dressed when they were in parish
churches, moradas, or homes. Although carved and painted with
clothing, bultos were usually also dressed with clothes often either
made or paid for by parishioners and donated to the church.*

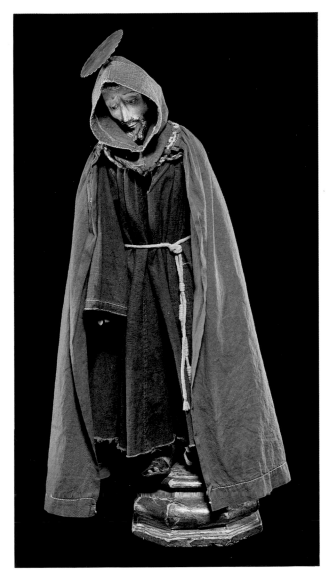

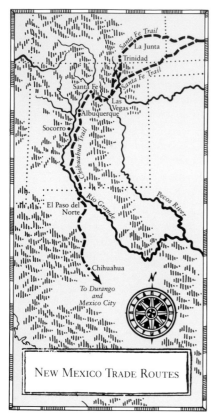

NEW MEXICO TRADE ROUTES

An Alter was erected, by placeing a table or bench in a room against the wall. Covered with a sheet, and the *Santo* placed upon it surrounded with tinsel, and gay colored paper flowers. The women baked bread in the [*h*]*ornos*, and cooked other foods, chili, beans, and meat if they had it.

In the morning of the day on which the *velorio* was to be held, some boy would be sent out to invite friends and relatives. The man of the family would make arrangements with the *Resador*, who was to take the leading part in the *velorio*. Do the praying and sing the *Alabados*. He was paid in grain or as it sometimes happened, a load to two of wood was hauled for him in pay. Just as soon as it became dark, those invited would arrive in wagons, horse-back, and on burros. Bringing all the children and the *viejitos*, "Old ones." These *viejitos* loved *velorios*,—unless sick—never failed to attend them.

As soon as all were there, singing and praying would go on until mid-night. Then a supper was served. After supper the singing was continued until dawn when the *Alba* was sung, then all would leave for home.[22]

By the late nineteenth century, the demand for locally produced religious art had begun to decrease. A number of factors contributed to this decline. Starting with the 1818 inspection of the churches by an ecclesiastical inspector from Durango, Mexico, there was increasing pressure from church officials in Mexico—and later those in the United States—to replace handcrafted images considered unfit for use in the churches with images that resembled those found in churches throughout central Mexico and the United States. This pressure coincided with increased accessibility to mass-produced items that were brought along as trade on the Santa Fe Trail beginning in 1821. Gradually, the drop in demand diminished the number of local workshops, some of which were followed by the itinerant artists of the late 1800s, who traveled from town to town seeking commissions, and once again by artists who supplemented their living by a number of means.[23] Many of these later

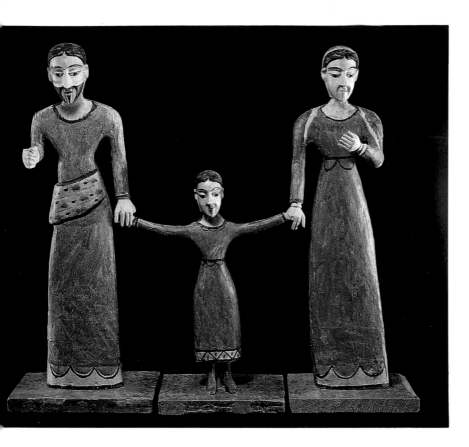

La Sagrada Familia / The Holy Family
José Benito Ortega (1858–1941),
 New Mexico, 1875–1907.
Gesso and water-soluble paint on
 wood, H. 22¾ in., ASF

Ortega was one of the last santeros working in the colonial tradition in late-19th-century New Mexico. His career was predated by New Mexico's first documented sawmill, installed by the American army in 1846, and his distinctive style owes much to that development. His use of milled boards and the resulting flat profiles of his figures caused his style to be initially called "flat figure."

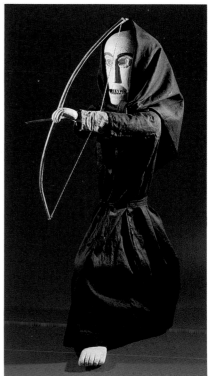

La Muerte / Death
García, Colorado, late 19th century.
Gesso and oil paint on wood, cloth and glass,
 H: 42 in., SCAS

Like the momento mori of academic European art, the figure of death was used in New Mexican Hispanic art as a reminder of human mortality and Christ's triumph over death. As penance during Holy Week, the members of the Penitente Brotherhood placed an image of death on a cart filled with stones and pulled the cart in their procession to Calvary. Such an image was often clothed as a woman, with long garments and shawls over her head, and known as Doña Sebastiana. The origin of the name Doña Sebastiana is unclear, although it may be related to the martyrdom of St. Sebastian, who was killed with arrows. The use of the death figure in processions, as well as death's identity as a female, has a long history in both Mexico and Spain (Wroth 1991).

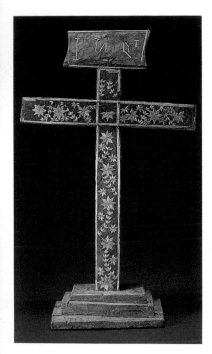

Cruz / *Cross*
Mexico, 19th century.
Wood, straw, 19¾ × 12 × 5⅛ in.,
CDC

works were commissioned by or made for the Brotherhood of Our Father Jesus of Nazareth, known locally as the Penitentes. Images made for the Penitentes were often used in their processions and reenactments of the events of the Passion during Holy Week.[24]

While Catholic faith was materially manifested in the *santos de bulto y de retablo* that graced both homes and churches, a number of items made for daily use also reflect the community aesthetic of Spanish colonial New Mexico. Weavings, *colcha* (couching stitch) embroidery, furniture and woodwork, tinwork and ironwork were all utilitarian items that were at the same time artistic expressions of the culture. Like *santos*, most of these items were created in the home or in small family-based *talleres*, where father taught son, mother taught daughter, and uncles, aunts, cousins, in-laws, and godparents could be involved in production in varying degrees. Bernardino Sena, mentioned earlier, operated a blacksmithing forge in Santa Fe that was run by his family until the 1920s; several members of the Ortega and Lucero families in Santa Fe were listed as carpenters in the 1700s and 1800s[25]; and the Ortegas and Trujillos of Chimayó trace their weaving heritage through eight generations.[26]

Though few early artists responsible for making furnishings and implements are known by name today, different hands and different styles can still be distinguished. The work of only two or three named tinsmiths has been positively identified, but most of the nineteenth-century tinwork found in New Mexico can be attributed to thirteen workshops.[27] Various types of joinery and decorative motifs have aided in the identification of stylistic attributes among the *carpinteros* (skilled woodworkers), and varying patterns and methods of application reveal an individual touch in the art of straw appliqué. Unlike the imagery of the *santos*, which was strictly dictated by the Catholic church, other media, while still expertly manipulated, allowed more freedom in expression and interpretation. Some evidence exists that Hispanic tradesmen collaborated with and were influenced by the region's Native Americans.[28]

Marco / *Frame*
Isleta Style, Central New Mexico,
 1890–1920.
Tin, 31¼ × 25⅜ in., SCAS

In the second half of the 19th century, food supplies were brought to the U.S. Army in New Mexico over the Santa Fe Trail in large square and round-bottomed tin cans. This frame, from which the print has been removed, clearly illustrates the reuse of the tin from these cans by the New Mexican tinsmith. The label reads: "The Colorado Packing and Provision Co. Lard Compound. Denver, Colo."

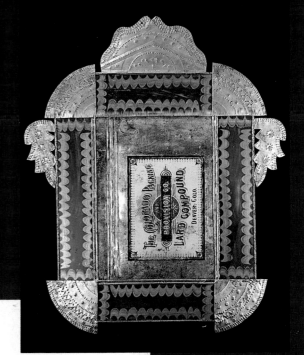

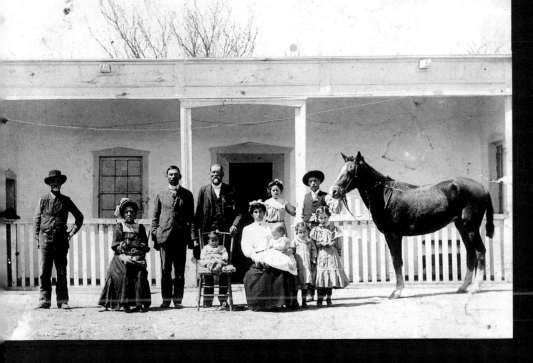

An extended Hispanic family: from left: Ramón Romero, Juanita Romero, Juan Fernández, Ramón Córdova, Juan Fernández, Jr., Eulalia Romero, Carlos Romero, Bernardita Fernández, Josefita Romero, Elvira Romero, Donaciano Romero, "Poli." Córdova, New Mexico, ca. 1910. Helen R. Lucero Collection.

Nicho con Estampa / Niche with Tin Frame
Río Arriba Painted Style, New Mexico, 1880–1900.
Tin, 11½ × 12 in., FH

Many tin frames made in New Mexican workshops were
designed to hold specific prints of saints and holy persons.
In the 20th century, these are sometimes used as didactic
tools by parents in teaching family and community values:
"Dispensed at churches or purchased in religious specialty
stores. . . . Parents refer to the estampas as they recount
the heroic episodes depicted, both socializing their children
and introducing them to the tenets of the Catholic church.
The saints of the estampas become guides to proper behav-
ior and are many a child's first encounter with traditional
Christian symbols" (Ybarra-Frausto 1990).

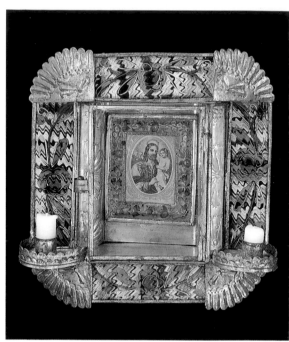

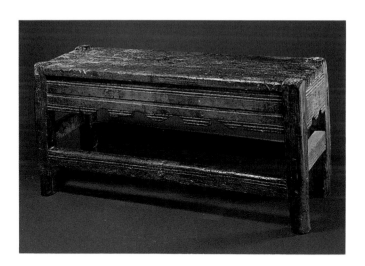

Tarima / Bench
New Mexico, 19th century.
Wood, 14 × 29¾ in.
Loan from Mrs. Cornelia G. Thompson.

Charola / Bowl
La Puebla, New Mexico, 19th century.
Wood, 5⅝ × 12 in. (diam.), HSNM

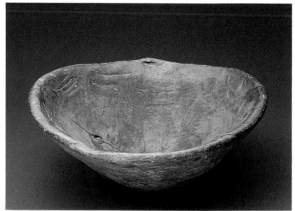

Repisa / Hanging Shelf
New Mexico, late 19th century.
Oil paint on wood, 20⅞ × 36⅝ × 6 in.,
MNM

This piece was once painted red with
black edging.

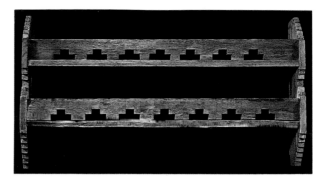

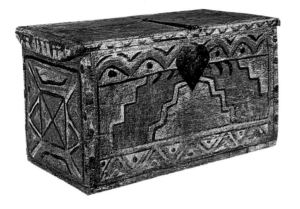

Caja / Chest
New Mexico, late 18th–early 19th century.
Gesso and water-soluble paint on wood,
17⅛ × 29 × 15 in., SCAS. Photo by Mary Peck.

The design on this painted chest seems to have been de-
rived from Native American motifs while the construction
of the chest, with dovetailed joinery, indicates European
woodworking techniques.

Hispanic homes are generally described as bare by nineteenth-
century Anglo visitors, but they were in fact adequately furnished with
built-in *bancos* (benches), *alacenas* (wall cupboards), and *nichos*
(niches). *Colchones*, or mattresses, were placed upon the *bancos* as
cushions and then unrolled on the floor for sleeping, covered with pat-
terned woven blankets. Movable furniture included *armarios* (armoires)
and *trasteros* (cupboards) used for storing clothing, dishes, and food-
stuffs. Numerous *cajas* (chests) were noted in most household inven-
tories. They "seem to have generally been used to hold clothing and
textiles, although there are also references to papers, tobacco, chocolate,
and even sacks of gold being kept in them."[29] Other types of furniture
listed in wills and inventories included chairs, stools, tables, and, in the
later 1800s, daybeds.

Inventories of churches in the 1800s indicate that, aside from eccle-
siastical furnishings such as altar cloths, chalices and patens, vestments,
and missals and bibles with stands (*atriles*), they were outfitted with fur-
niture, tinwork, and wooden candelabra, many of which probably were

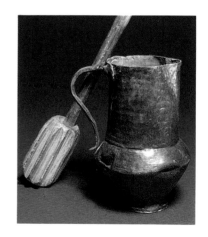

Chocolatera / Chocolate Pot
Mexico, 19th century.
Copper and tin, 14 × 6 in., MNM

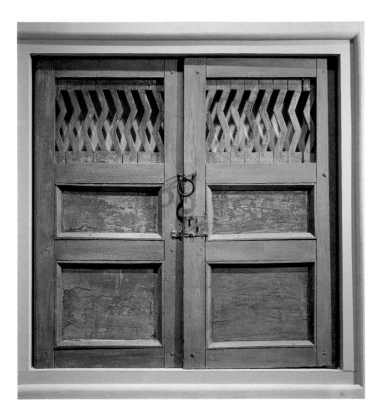

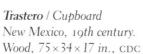

Puertas para Alacena / Doors for
 Cupboard
New Mexico, late 19th century.
*Oil paint on wood, each 36×17×3
 in.*, MNM

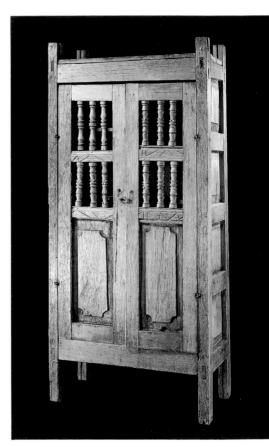

Trastero / Cupboard
New Mexico, 19th century.
Wood, 75×34×17 in., CDC

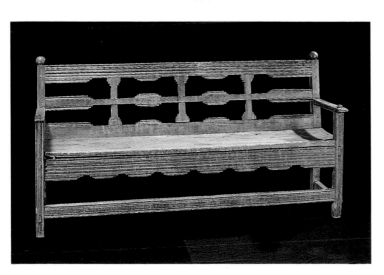

Banco / Bench
New Mexico, early 19th century.
Oil on carved wood, 33½×64×19¼ in.,
 MNM

Trastero / Cupboard
New Mexico, late 19th century.
Oil on wood, 80½ × 35¾ × 12¼
 in., FH, IFAF

Painted dark green with red pomegranate
motifs on its side panels, this trastero has
three shelves on the top half and twelve
small drawers below.

Caja / Chest
Peñasco Valley, New Mexico, early
 20th century.
Oil on wood, 15½ × 33 × 17½ in.,
 CDC. Photo by Mary Peck.

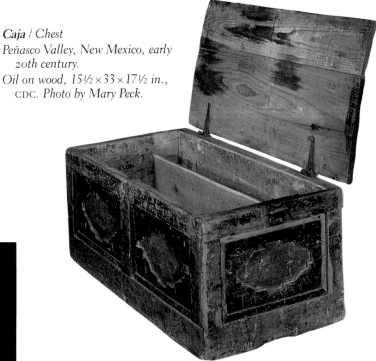

Caja / Chest
New Mexico, late 19th century.
Oil on wood, 17½ × 43¼ × 20⅛ in.,
 SCAS. Photo by Mary Peck.

The design of this chest reflects the neoclassical style that became
popular in New Mexico in the late 19th century. The mitred
molding was used to form a coffered design similar to that popu-
lar on neoclassical ceilings in Mexico and the United States.

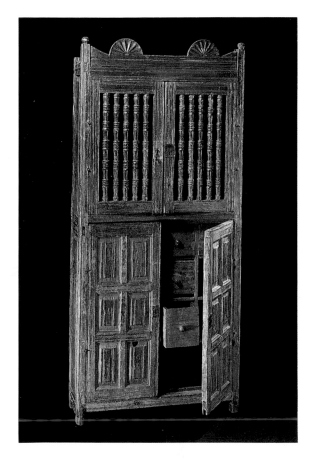

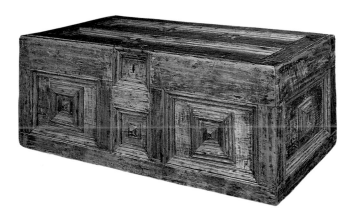

***Gramil* / Joiner's Marking Guage**
Guanajuato, Mexico, 19th
 century.
Iron, wood, 3¼ × 5¼ × 1½ in.,
 IFAF

This wood-marking tool, similar in
use to a compass, also resembles a
washer cutter.

made locally. An 1818 inventory made at the church of Nuestra Señora del Rosario in Truchas lists, in addition to the altar screen, *bultos*, and *retablos*, a tin wafer box (*un ostiario de oja de lata*), a large chest, two confessionals, six wooden candlesticks, a bench, a chair, the door to the chapel, a wooden pulpit, and a small wooden table (*que dio un Devoto*).[30]

In Mexico, formal guilds had been established in the sixteenth century that strictly regulated what was made, its materials, form, and exact dimensions, and who could properly make it. Ordinances of the carpentry guild, for instance, established in Mexico City in 1568, spelled out specific terms and conditions of admission and work for both masters and apprentices to follow. The *carpintero* was required to know not only how to make numerous types of joints but, in order to build altar screens, he had to be familiar with the classical orders of architecture.[31] Although there was no formalized guild system in New Mexico, carpenters were skilled artisans conversant with rules of proportion and joinery along with their technical application to raw material. Designs were based primarily on Mexican and Spanish artistic traditions. For instance, New Mexican chests-on-legs were probably derived from a combination of the northern Spanish chest with extended stiles with the

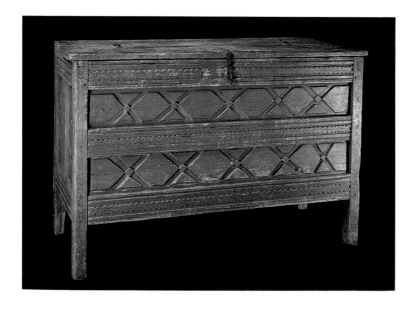

***Caja* / Chest**
Manzano, New Mexico, 19th century.
Oil on wood, 40 × 60½ × 25½ in.,
 MNM

The "X" motif on this chest has been
traced to the Manzano area south of
Albuquerque (Taylor and Bokides
1987).

Retablo / *Altar Screen*
Rafael Aragón (ca. 1796–1862), New Mexico, 1830–62.
Gesso and water-soluble paint on wood, 130 × 61¼ in., IFAF

Beginning in the mid-14th century, altar screens became the focal point of decoration in the churches of Spain (Sobré 1989). The tradition was carried with the Spanish colonists to New Spain. This altar screen, used in the morada *(chapel) of the Brotherhood of Our Father Jesus of Nazareth in the town of Vadito, exhibits typical construction. The* remate *at the top usually displayed an image of one of the members of the Holy Trinity. Below this were two or three horizontal tiers (cuerpos) containing bays with images of saints and the Holy Family set in an often elaborate architectural framework. These bays, which in Mexico would have been filled with oil paintings or sculptural images, in New Mexico had images painted directly onto wooden panels set into the* retablo *framework. One niche in the central bay was always reserved for an image of the patron saint of the church or chapel. Usually this was a* bulto *that could be removed for use in processions and for changes of costume in accord with the liturgical seasons.*

Hostiario / *Wafer Box*
Taos, New Mexico, 19th century.
Tin, 1¾ × 4 in. (diam.), HSNM

Father José Antonio Martínez used this tin wafer box to hold the unconsecrated host during his tenure as a priest in Taos from 1826 to 1867.

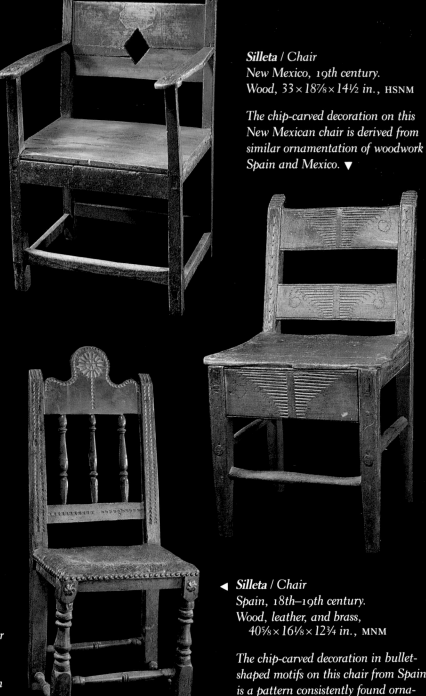

Sillón / Armchair
New Mexico, 19th century.
Wood, 35¼ × 22¼ × 20⅝ in., HSNM

*This sillón de frailero (priest's chair) is
said to have been used by Padre Anto-
nio José Martínez of Taos, who
operated a private school and ran New
Mexico's first printing press.* ▶

Silleta / Chair
New Mexico, 19th century.
Wood, 33 × 18⅞ × 14½ in., HSNM

*The chip-carved decoration on this
New Mexican chair is derived from
similar ornamentation of woodwork i
Spain and Mexico.* ▼

▲

Sillón / Armchair
San Nicolás de las Carretas,
 Chihuahua, Mexico, ca. 1830.
Wood, 34⅝ × 21⅛ × 19⅛ in., SCAS

*The mortise-and-tenon construction, angular
form, and narrow arms resting on extended
front legs are characteristic of the sillón de
frailero, a chair design developed in Spain in
the early 16th century and imitated in Mex-
ico and New Mexico (Pierce 1989).*

◄ **Silleta** / Chair
Spain, 18th–19th century.
Wood, leather, and brass,
 40⅝ × 16⅛ × 12¾ in., MNM

*The chip-carved decoration in bullet-
shaped motifs on this chair from Spain
is a pattern consistently found orna-
menting the colonial woodwork of
Mexico and New Mexico.*

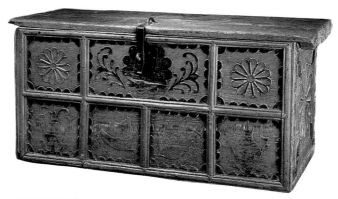

Caja / Chest
New Mexico, late 18th century.
Wood, oil paint, 20½ × 43¼ × 19¼ in., MNM

This chest, which has six interior drawers for storing smaller items, may have been made as a dowry chest. The relief-carved motifs of lions, pomegranates, and rosettes date back to the Byzantine era and were standard baroque design elements in the furniture of both Spain and Mexico.

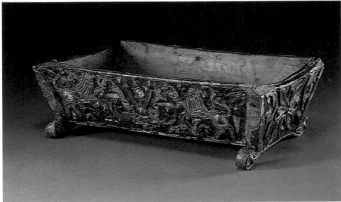

Cuna de nacimiento / Nativity Cradle
Lorenzo Ortega, New Mexico, 1789.
Gesso and oil paint on wood, glass,
3½ × 11½ × 6¾ in., ASF

This piece, inscribed "De mano de Lorenzo Ortega año de 1789," is one of the only dated and signed pieces of woodwork from colonial New Mexico. It has dovetailed joinery with elaborate, rococo-inspired relief-carved decoration that includes paste jewels and *leos pardos, an unusual motif in New Mexican woodwork.*

Spanish *vargueño*, or writing desk; the armchair, or *sillón*, design was based on the *sillón de frailero* (priest's chair) popular in Spain and Mexico.[32]

Wooden surfaces were decorated in a variety of methods—relief carving, painting, and straw appliqué. Motifs of pomegranates, rosettes, vines and scrollwork, and opposed lions were in demand, as well as purely geometric and abstract floral compositions. These designs were either rendered in relief and then painted or else painted on the flat, gessoed board.[33] Straw appliqué was sometimes used to form the decoration on a solid background. Both the motifs and designs on these pieces reflected the current artistic trends of the time, ranging from a baroque love of ornament to a later and more austere neoclassical statement.

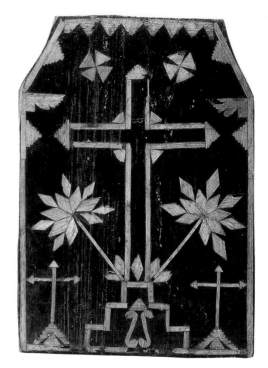

Placa / Plaque
New Mexico, late 18th–early 19th
century.
Wood, straw, 12 × 8¾ × ¾ in., HSNM

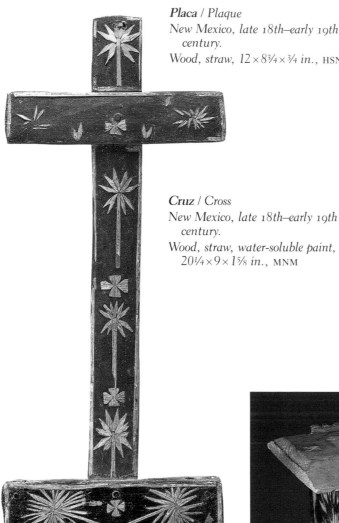

Cruz / Cross
New Mexico, late 18th–early 19th
century.
Wood, straw, water-soluble paint,
20¼ × 9 × 1⅝ in., MNM

Caja / Box
New Mexico, late 18th–early 19th
century.
Wood, straw, 7⅛ × 10 in., HSNM

Even the fabrication of something as seemingly elementary as a wooden plow had particular specifications and required a specific knowledge. As José Gurule and Benino and Concepción Archibeque recalled in 1942:

> In the early days of old Las Placitas the men and the women were forced through necessity to make every tool and implement with which they worked. Consequently those who possessed vision as well as skillful hands became of importance in the village. . . . So it was that Salvador has long been remembered for the plows he made. . . .
>
> Salvador's plows were his pride. He made them with utmost care and skill and they performed the work he built them to do. Much depended upon the pine tree he selected from which to make his plow. He spent many days tramping through the hills and *cañoncitos* in search of just the right trees. After he found them there was the work of chopping them from the limbs he selected, and the dragging of the limbs to his workshop behind his house. . . .

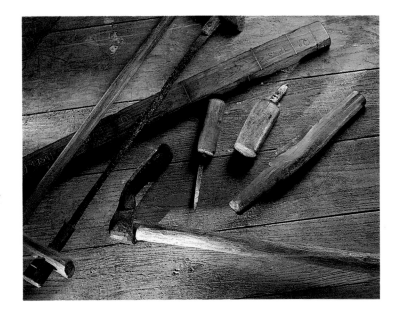

Herramientas para Tallar Madera /
Woodworking Tools
New Mexico, late 19th century. SCAS, MNM, HSNM

Left to right: bow saw, vara (measuring stick), adz, awl, knife, and drawknife. The saw was used for cutting smaller pieces of lumber as well as to make curved cuts; the vara stick was the standard unit of measurement during the colonial period and is roughly equivalent to a yard; the adz was used to dress lumber; the awl was a hole-punching tool; this small knife would have been used for finer, detailed finish work in carving; the drawknife, one foot in length, used by tanners to scrape hides, was also probably employed to shave the bark off logs (Simmons and Turley 1980).

When the limb for a plow was trimmed and smoothed it must measure about six inches in diameter. One of the forks must be about thirty inches long, the other about thirty-six inches long, and the angle of the fork of the limb must be around seventy degrees. The longer portion of the forked limb was called *la cabeza*, the head. That part of the fork became the part of the plow that was pulled over the ground. The shorter length of the forked limb became the *mano* and stood up and it became the handle of the plow. One of the most important features of the plow was the point, *la punta*. It was made of piñon wood. It corresponded in size of diameter to the *cabeza*, was cut to a good, strong point and attached to the *cabeza* at an angle, downward, with pins four inches long made of *encina* (oak). These pins were stout and thick. Whenever a point needed to be removed from the *cabeza* for replacement with a new point, usually new pins were used.

The next feature to be added to the plow was the frame, *el telar*. It also was of piñon, and was placed upright and attached to the

Arado / Plow
*Taos, New Mexico, late 19th–
early 20th century.
Wood with iron plowshare,
44½ × 67 × 4 in.,* HSNM

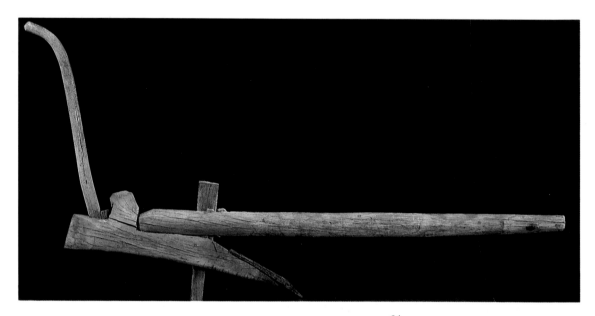

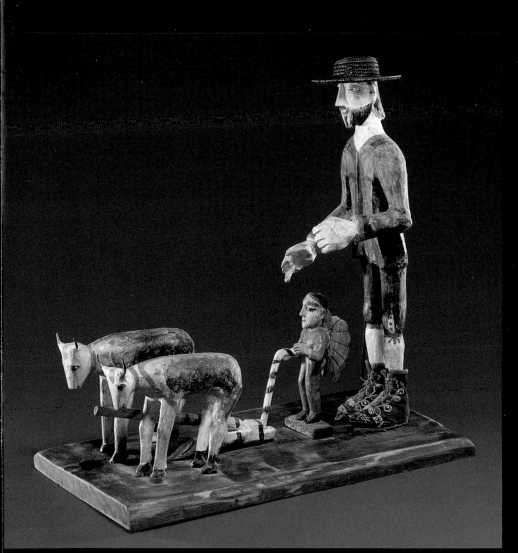

San Ysidro Labrador /
St. Isidore the Farmer
José Benito Ortega (1858–
1941), New Mexico,
1875–1907,
Gesso, leather, beads, and
water-soluble paint on wood,
18¼ × 11⅜ × 16³⁄₁₆ in., CW

San Ysidro, the patron saint of
Madrid and of farmers, was
born to a poor family in Madrid
in the year 1070. As soon as he
was old enough, he went to
work for a wealthy landowner,
Juan de Vargas, an ancestor of
New Mexico's Don Diego de
Vargas. He won both respect
and admiration during his life-
time for his generosity and pious
deeds. San Ysidro was canon-
ized in 1622. The attributes
usually depicted with the
saint—the oxen, plow, and an-
gel—derive from one of the
miracles associated with him:
Juan de Vargas became enraged
with San Ysidro because he
often neglected his work in the
fields in order to pray. One Sun-
day, Vargas was on his way to
punish Ysidro for his negligence
when he was astonished to find
that the oxen and plow were
being guided by an angel in Ysi-
dro's stead while the latter
kneeled in prayer.

middle of the head with strong oak pins. Its function was to support the *timón* (beam) which was attached with huge oak pins to the angle of the fork. This *timón* was of piñon, at least ten feet long and of a thickness to stand the pull or strain that must be put upon it; as this *timón* was the equivalent to a wagon tongue, by which the oxen would draw the plow. Then there was the *yugo* (yoke), or *llugo*, as Salvador himself spelled it. He made them also. A plow was useless without a *yugo*, which was a smooth, straight pole about seven feet long or more, if needed, and of a thickness needed, which depended mostly upon the size of the oxen. This *yugo* was tied to the horns of the oxen and the center of the pole was tied to the tip of the *timón* with a rope made of leather.[34]

Nothing about the execution of these items was haphazard. There were specific sets of rules to be followed, and specific proportions that fulfilled both functional and aesthetic goals, and the artist needed to have a familiarity with the necessary raw materials along with the expertise to carry out the design.

Although little is known of metalworking in the seventeenth and eighteenth centuries in New Mexico, evidence from the nineteenth century indicates that there were efficient and skilled metalworkers in the area. *Plateros*—artists who worked in either silver or gold—were producing work that was of a quality to be admired by often-critical visitors from the United States. In the 1830s, trader Josiah Gregg noted: "Gold and silversmiths are perhaps better skilled in their respective trades than any other class of artisans whatever. . . ."[35] Lieutenant James Bourke, who came to New Mexico as an officer at Fort Craig in 1878, stated: "I began my rounds this morning by inspecting the lovely silver-ware at Lucas' and yielding to the temptation of purchasing some of the exquisite filagree [*sic*] work spread out for my inspection."[36]

While few works have been traced to an identifiable artist, the items were often created in family-based *talleres* or in workshops set up by local merchants.[37]

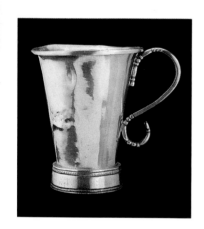

Taza / Cup
New Mexico or Mexico,
19th century.
Silver, H: 4⅛ in., MNM

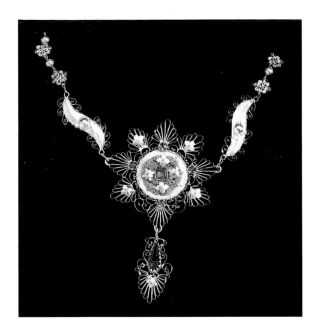

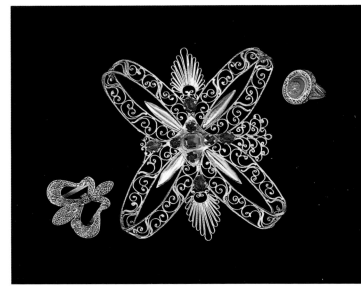

Gargantilla / *Necklace*
New Mexico, 19th century.
Gold filigree, glass, 8⅛ × 3½ in., MNM

According to oral tradition, New Mexican suitors of the late 19th century were required to provide their fiancées with sets of filigree jewelry, including an elaborate necklace with pendant, as shown here (Weber 1982–83).

The skill of the *platero* may have lent itself to a new art form that appeared in the later nineteenth century—that of the tinsmith. Fueled with materials previously unavailable, such as tinplate, glass, and wallpaper, the New Mexican tinsmith combined these resources from the United States with techniques and styles drawn from Mexico. The tin frames, candle sconces, chandeliers, and processional crosses turned salvaged tin cans, brought via the Santa Fe Trail to supply U.S. military forts, into affordable decorative objects reflecting the current revival tastes of metropolitan centers to the south and east.

Ironworking was a particular challenge in all of the Spanish colonies because of the scarcity of raw material. The principal reason for this was Spain's desire to keep a monopoly on the iron trade with her colonies in the Americas, thereby restricting both trade from other coun-

Filigrana / *Filigree*
New Mexico, late 19th century.
Gold; ring is ¾ in. in diameter,
SCAS, MNM

J. S. Candelario owned and operated a curio shop in Santa Fe from 1885 to 1914, where he employed a number of filigree jewelers who made items for sale in his shop. This ring, from Candelario's estate, was probably made by one of those workers; the fleur-de-lis brooch is stamped "JSC" on the back. The large pendant, to be worn with a necklace, has glass jewels.

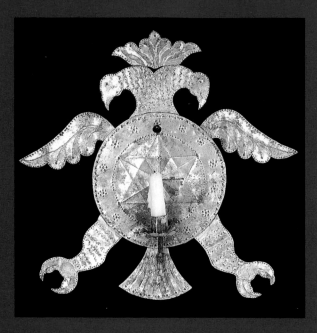

Candelabro de Pared / *Candle Sconce*
Federal Style, New Mexico, 1860–75.
Tin, 17½ × 17¾ in., MNM

This candle sconce is an excellent example of the influence of the design motifs used in Mexico. The double-headed eagle, an image that goes back to Byzantine times, was the heraldic symbol of the Austrian Hapsburgs, who ruled Spain from 1516 to 1700.

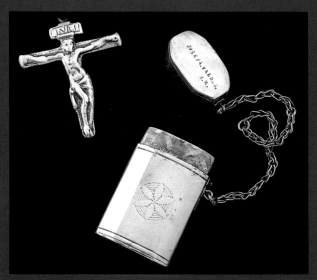

Crucifijo / *Crucifix*
Tabaquera / Tobacco Flask
Mexico (left) and New Mexico, late 19th century.
Silver; crucifix is 2⅞ in. high, HSNM

Stamped into the top of the flask are the words "Josefa Valdez / N.M.," probably a reference not to the maker but to the owner.

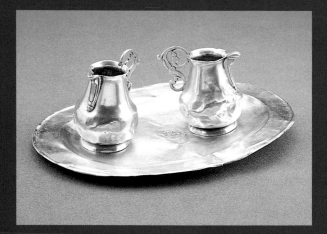

Juego de Vinajera / *Wine Vessels for Mass*
New Mexico or Mexico, 18th–19th century.
Silver, 3½ × 9¼ × 6½ in.
Loan from Ambassador and Mrs. Frank Ortiz

Although no silver work has been definitively linked with a named colonial New Mexican platero, the objects shown on these pages are those that were commonly used in New Mexico and are often mentioned in historical documents.

tries and iron production in New Spain.[38] In Mexico, as in Spain, separate guilds were established for locksmiths, blacksmiths, and farriers, but in New Mexico, where raw material was even scarcer because of the long distances from distribution centers, it was not uncommon for the blacksmith to fill all these roles and to be a *platero* as well.[39] The ornate designs derived from the Moors in Spain and found in the grill-work and architectural details in Mexico were rarely seen in New Mexico. Instead, most of the available iron was put to utilitarian tasks, with items reused and reshaped as the need arose.

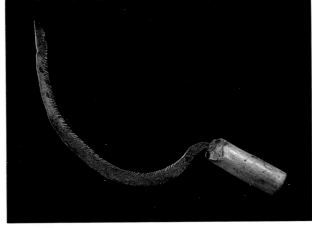

Tenamaste / Trivet
New Mexico, late 19th century.
Iron, 6 × 14½ × 9¼ in., MNM

This trivet is an excellent example of the reuse of iron, which was scarce throughout the Spanish colonies. The top of the trivet is fashioned from the ring of a buggy wheel while one of the three legs is a railroad spike. Trivets like this were commonly used to hold round-bottomed cooking pots over the fire in the corner fireplace.

Hoz / Sickle
New Mexico, 19th century.
Iron, wood, 14¼ in. long,
HSNM

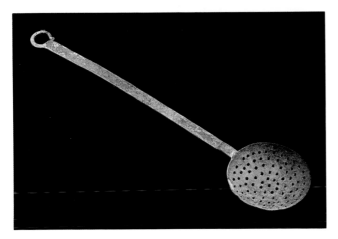

Espumadera / Skimmer
La Joya, New Mexico, 19th century.
Iron, 22⅝ in. long, HSNM

Although the Pueblo Indians were accomplished weavers in cotton when the Spanish arrived in New Mexico, the settlers chose to continue using two items that were traditional to Spanish weaving. The first was the fleece of a hardy type of sheep called *churro* that was ideal for hand spinning. The second was the treadle loom on which could be produced long lengths of fabric. However, as both cultures began to learn about the materials and techniques of the other, design styles evolved that sometimes combined traditional motifs.

Textiles were an important trade item to Mexico throughout the colonial period, but textile exportation peaked in 1840 when more than twenty thousand textiles were being exported to Mexico.[40] Three major types of textiles were produced on Hispanic looms: *sabanilla, jerga*, and Rio Grande blankets. *Sabanilla* was a plain-weave wool cloth used for clothing, mattresses, and as backing for *colcha* embroidery. *Jerga* was a coarse twill weave used for floor coverings and saddle blankets. Rio Grande blankets, in a variety of patterns, were weft-faced weavings used primarily as bedding and seating. As with other areas of endeavor, certain members of a community were known for their technical skill in textiles, as well as their ability to conceptualize a design, skills that were passed on through generations.[41]

The *colcha*, or couching stitch, is an embroidery stitch that has been used in New Mexico since the mid-eighteenth century, with the earliest identified *colcha* embroideries consisting of hand-spun wool embroidery yarns stitched onto *sabanilla*. The *colcha* stitch was used to entirely cover the loosely woven backing with geometric and floral motifs. By the mid-nineteenth century, commercially woven cotton backing replaced the *sabanilla*, and new design motifs were used that did not cover the entire ground. Designs were often derived from Chinese embroideries on silk that came to New Mexico in the form of altar frontals and from East Indian chintz fabrics, both of which were imported into New Mexico in the 1700s.[42] Some designs were obviously derived from the embroidery of Spain and Mexico, already strongly influenced by the Moors, but the *colcha* stitch apparently was never used in these countries, although it was used in Portugal.[43]

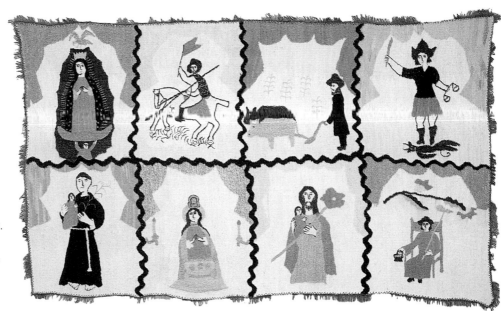

Carson Colcha / *Embroidery*
Carson, New Mexico, ca. 1920.
Wool on wool, vegetal and
aniline dyes, 47¼×78¾ in.,
MNM

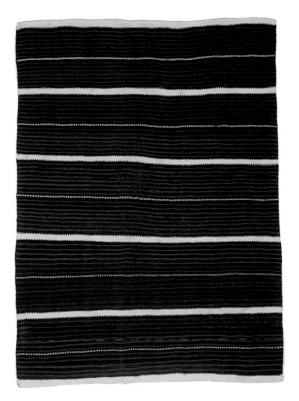

In the 1930s, a new form of design originated in Carson, just north of Taos. Using recycled materials, such as pieces of old sabanilla (plain-weave wool cloth) and raveled yarns from old Rio Grande blankets, these colchas featured pictorials and narrative scenes, with images of saints, herds of buffalo, wild horses, and wagon trains (MacAulay 1992). The saints depicted in this Carson colcha are, from top, left to right: the Immaculate Conception, St. James the Moor Slayer, St. Isidore, St. Michael, Archangel, St. Anthony, Our Lady of St. John of the Lakes, St. Joseph, and the Holy Child of Atocha.

Frazada / *Blanket*
New Mexico, mid-19th century.
Wool, vegetal dyes, 70×50½ in., Loan from the
Museum of Indian Arts and Culture, MNM

Purchased on the Navajo Reservation in 1887, this blanket was made by Native American weavers. It is, however, very close in design to the Rio Grande banded blankets made by Hispanic weavers.

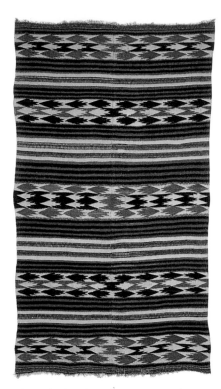

Frazada Río Grande / Rio Grande
 Blanket
New Mexico, 1860–70.
Wool, vegetal dyes, 85×46⅞ in., MNM

*This Rio Grande striped blanket has a
palm leaf tapestry design that was
adapted from the serapes made in Sal-
tillo, Mexico, in the colonial period.*

*"Appearing to be an unwieldy and clumsy instrument, the
Spanish loom was actually a sophisticated piece of ma-
chinery. Unlike the Indians' vertical loom, the Spaniards'
horizontal loom made it possible to weave seemingly infi-
nite lengths of yardage without interruption. The narrow
loom reeds, made of wood until about 1880 when metal
reeds became available, were one of the only limiting fac-
tors. Many Spanish colonial blankets have a telltale ridge
in the center attesting to their having been double woven.
This weaving technique doubled the width of the finished
piece and circumvented the limitations of the narrow wood
reed" (Lucero 1987). Photo by T. Harmon Parkhurst, ca.
1935, Museum of New Mexico Photo Archives.*

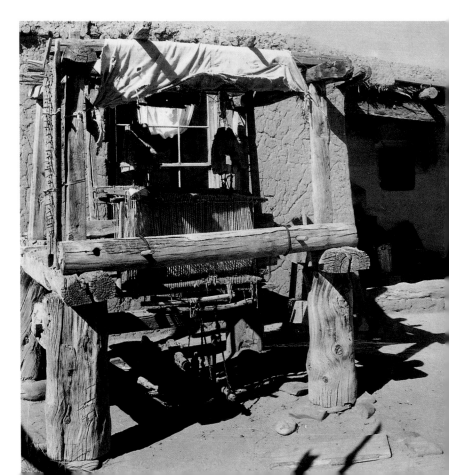

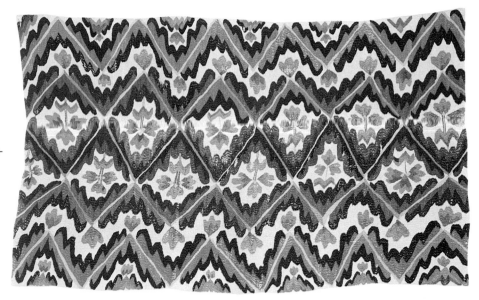

Colcha / Embroidery
New Mexico, 1830–50.
Wool on wool, vegetal dyes,
 83⅞×48¾ in., IFAF

Geometric and floral motifs
were typical designs on the colo-
nial *colchas* made in New
Mexico. Pieces where the em-
broidery covered the entire
ground, such as this, are rare,
probably owing to the time-
consuming process.

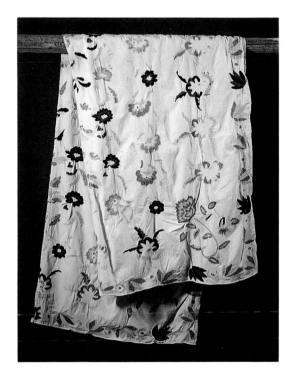

Colcha / Embroidery
New Mexico, ca. 1850.
Wool on cotton, vegetal dyes,
 84×52 in., SCAS

Jerga / *Floor Covering*
New Mexico, mid-19th century.
Wool, aniline dyes, 168½ × 62¾ in., MNM

"Jerga *(a thick, coarse cloth) was used in Spanish Colonial New Mexico for clothing, packing material, and most frequently, as a floor covering. When used as a floor covering,* jerga *was either placed directly on the packed earth floor or atop a layer of straw or snakeweed. The snakeweed (yerba de la víbora) deterred mice and insects. Many documents, including Vargas's 1704 will, mention the existence of the four-harness, twill-woven* jergas" *(Lucero 1987).*

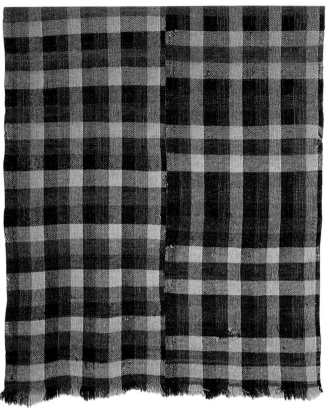

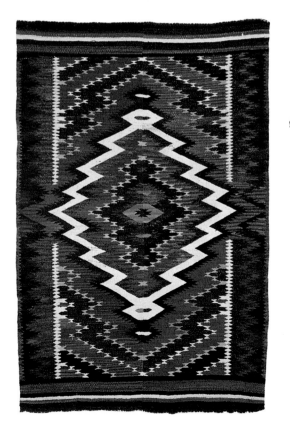

Frazada Río Grande / *Rio Grande Blanket*
New Mexico, ca. 1880.
Wool, cotton, aniline dyes, 78¾ × 55⅛ in., IFAF

In the second half of the 19th century, several events affected the character of Hispanic weaving. The introduction of the rambouillet and merino sheep, which produced more meat but had inferior wool, led to the virtual extinction of the churro and its superior wool. The availability of synthetic dyes and readily available commercial fabrics contributed to a decline both in the quality and quantity of New Mexican Hispanic weavings. This example shows the coarser, shorter fleece of the Merino sheep and the non-colorfast aniline dyes.

The market in territorial New Mexico for handcrafted, nonreligious items, as for its religious counterpart, diminished by the late nineteenth century. Competition from eastern U.S. markets steadily increased after the arrival of the railroad in 1879, and by the turn of the century there appear to have been fewer Hispanic artists working in New Mexico. Those who were working, however, continued the traditions and expanded upon them. Among them were *santeros* José Benito Ortega of Mora, Miguel Herrera of Arroyo Hondo, Juan Ramón Velázquez of Canjilón, and José de Gracia Gonzales of Ranchitos; tinsmiths José María Apodaca of Santa Fe and Higinio V. Gonzales of San Ildefonso; and *carpinteros* José Dolores López (also a *santero*) and his brothers of Córdova, Alejandro Gallegos of Peñasco, and Aniceto Garduño of Chacón.[44]

Most of the demand for these pieces was local. When Hispanic crafts were marketed nationally, they were sometimes advertised as being Indian made, with the merchants seizing upon the romantic revival nostalgia for exotic cultures. In 1925, several individuals, led by writer Mary Austin and artist Frank Applegate, founded the Spanish Colonial Arts Society and undertook to create a new market for the traditional

Cofre para Dijes / Trinket Box
José María Apodaca (1844–1924),
 Ojo de la Vaca, New Mexico, 1890–1915.
Tin, 6 × 7¼ × 5 in., SCAS

José María Apodaca is one of the few named tinsmiths with whom a body of work is associated. From his home and studio in Ojo de la Vaca, southeast of Santa Fe, he traveled on horseback along the Pecos River to Santa Fe, where he sold his art. Apodaca's work is distinguished by its ornate surfaces decorated with small scalloped designs and the use of the golden-coated interior of tin cans (Coulter and Dixon 1990).

San José / St. Joseph
Juan Sánchez (1901–69),
 New Mexico, 1930s.
Oil on wood, H: 39 in.,
 HSNM

Sánchez, a santero who lived in Colmor, near Raton, was hired by the Federal Art Project to reproduce traditional santos.

Cruz / Cross (and detail)
Eliseo Rodríguez (b. 1915), Santa Fe,
 New Mexico, 1983.
Wood, straw, 96×48 in., IFAF

Eliseo Rodríguez revived the art of straw appliqué while
working with the WPA Artists Project in the late 1930s.
Since then, he and his wife, Paula, to whom he taught the
technique, have become the acknowledged masters of the
medium. Their daughter Vicki and grandchildren
Jessica and Marcial learned from them and continue
in the tradition.

Hispanic arts. The society not only opened a shop for the sale of these works but actively worked with the local schools to train students in the different artistic media. In the 1930s, the federal government stepped in. Under the umbrella of President Franklin Delano Roosevelt's New Deal, the Federal Arts Project of the Works Progress Administration provided an important economic incentive for foundering artists throughout the country. With the cooperation of the U.S. State Department of Vocational Education, a number of training schools were established. Through these programs, New Mexican Hispanics were schooled in traditional forms, techniques, and materials and were once again able to earn an income producing religious and secular objects, paintings, and textiles.[45]

Each of these items, from the wooden plow to the carved and polychromed *santo*, comprises the folk art of colonial New Mexico. Today, Hispanic artists continue to create objects that speak of a common history and a common aesthetic. Like their forefathers, these artists combine the qualities of tradition, community, craftsmanship, and religious spirit in an expression that is both unique and universal.

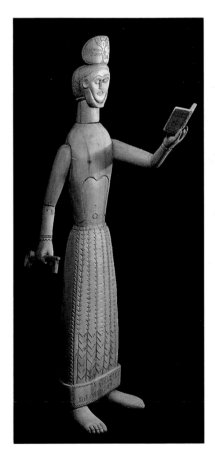

San Pedro / St. Peter
José Dolores López (1868–1937), Córdova, New Mexico,
 1930s.
Carved wood, H: 53½ in., Loan from Eva S. Ahlborn

José Dolores López lived in Córdova, the same village in which santero *Rafael Aragón, a relative by marriage, made his home. López's father, Nasario, was locally known as a* santero *and may have worked with Rafael Aragón (Briggs 1980). Despite the fact that much of López's early work was polychromed—painted in bright, colorful house paints—his reputation, and that of the Córdova wood-carvers that followed him, is based on intricately carved and unpainted wooden images, such as this image of St. Peter. The design motifs and carved decorative style bear close resemblance to those of provincial European woodwork. López's descendants continue as wood-carvers and imagemakers today.*

The Hispanic folk art of New Mexico is historically an unsigned art. As with much folk art from around the world, which is produced in contexts where a community aesthetic supersedes that of the individual, the names of Hispanic artists appear to have been insignificant to both the creators and the patrons. In a few cases, however, New Mexican *santos* were signed, and subsequent study and analysis have led to further attributions to the same artists. In other cases, distinctive stylistic traits have revealed the work of a single hand, or multiple hands from a single workshop. This section illustrates the work of some of those artists who are recognized as among the most prolific of New Mexico's historic *santeros*.

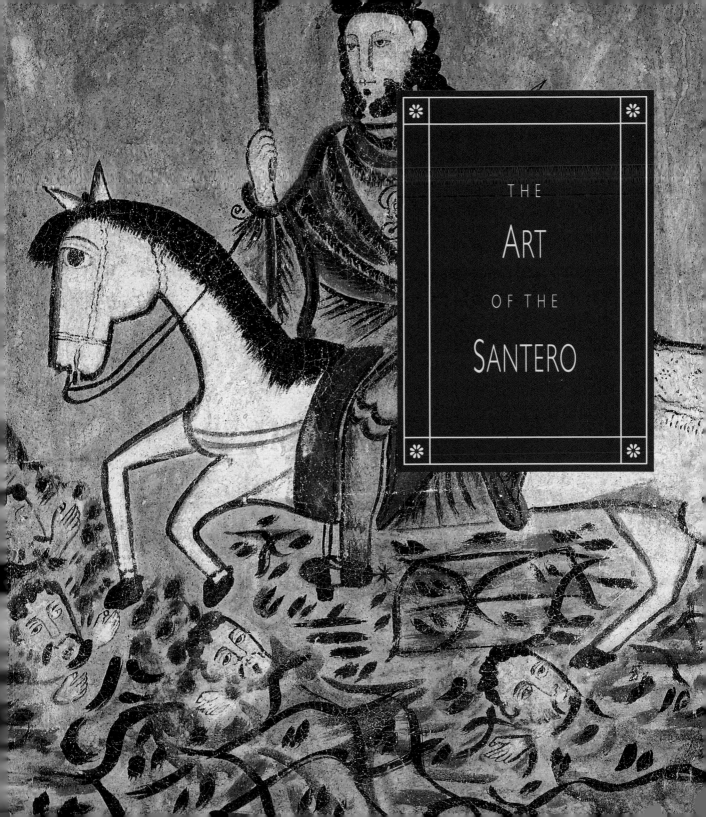

THE

ART

OF THE

SANTERO

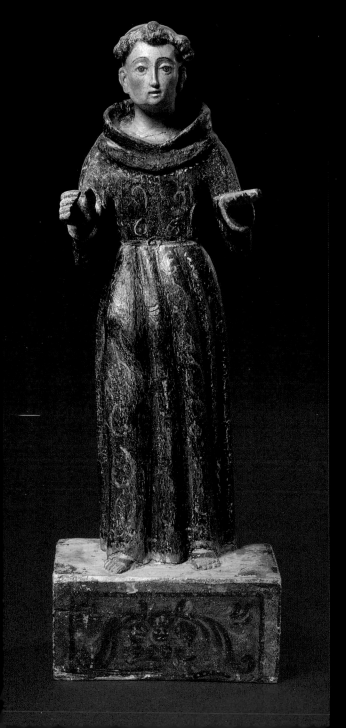

San Antonio de Padua / *St. Anthony of Padua*
School of Laguna Santero, New Mexico,
early 19th century.
Gesso and water-soluble paint on wood,
H: 19 in., FH

This bulto of San Antonio, which has been given
both a New Mexican and a Mexican provenance
(Boyd, Museum of International Folk Art cata-
logue files; Mather 1983), is an excellent example
of the technical and stylistic characteristics shared
by New Mexican and provincial Mexican imagery
of the late 18th and 19th centuries. The white
decorative details, the gessoed cowl and cuffs of the
saint's habit, and the floral motif on the base are
all indicative of both the style of the Laguna san-
tero and the prevailing late baroque detailing of
provincial Mexico (Pierce and Weigle, in press).

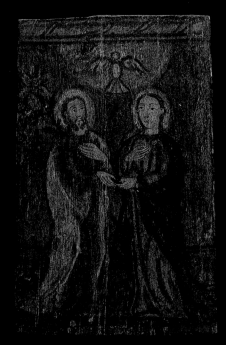

Los Desposorios de la Virgen / *Marriage*
of Mary and Joseph
School of the Laguna Santero, New
Mexico, early 19th century.
Gesso and water-soluble paint on wood,
15¼ × 9½ in., JEAF

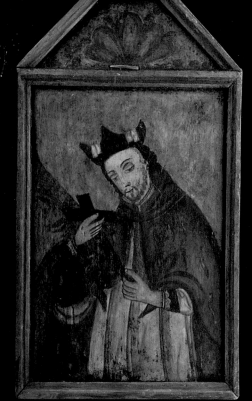

The Laguna santero, whose identity is unknown, was probably a Mexican artist whose major extant work is the altar screen at the church of San José at Laguna Pueblo (page 37). A number of other altar screens have been attributed to the same artist, all of which date between 1798 and ca. 1808, his period of work in New Mexico. These include the altar screens for churches in Santa Fe and the pueblos of Pojoaque, Acoma, Zía, and Santa Ana (Bol 1980). The Laguna santero's work is characterized by the dark, rich colors of Mexican baroque paintings, three-quarter-length portraits and a three-quarter view of faces, the use of a translucent white paint for details and decorations on clothing, the repeated use of certain motifs, and a distinctive way of rendering hands. Similarities between his work and that of some of the later santeros, particularly Molleno, indicate that he trained other artists in New Mexico and operated a possibly large-scale taller (Wroth 1982).

San Juan Nepomuceno / St. John Nepomuk
School of the Laguna Santero, New Mexico, early 19th century.
Gesso and water-soluble paint on wood, 13½ × 9¾ in., IFAF

San Juan Nepomuceno lived in the 14th century in Prague and was confessor to the Queen of Bohemia. The King of Bohemia tried in vain to force him to divulge the queen's confession; when he would not, the king had him tortured and thrown off a bridge to drown. He became a symbol for secrecy, the patron saint of Czechoslovakia, and the protector of the Jesuit Order. He is dressed in a white surplice over a black cassock. An almuce (short fur cape) covers his shoulders. A biretta is worn as headgear. The crucifix represents his devotion to Christ while the palm leaf symbolizes his martyrdom.

Nuestra Señora de los Dolores /
Our Lady of Sorrows
School of the Laguna Santero, New Mexico, early 19th century.
Gesso relief, gesso and water-soluble paint on wood, 12⅞ × 7¼ in., FH

This image is an example of gesso relief, where certain elements, such as the head, hands, sword, and folds in the garments, are built up with gesso to project from the surface of the panel, adding a three-dimensional effect. Owing to similarities in painting style, in decorative details, and in rendering of the figures, many gesso-relief panels are attributed to the Laguna santero workshop. The framed image with a triangular pediment and an inset scallop-shell motif is characteristic of these panels.

The body of work usually attributed to the artist known as Molleno is characterized primarily by a limited palette of reds, blues, and blacks; brief, feathery brushstrokes; and a consistent and systematic execution of design. Variations in his style are usually explained as early- and late-period works rather than the work of a different hand, such as an assistant. Similarities between Molleno's work and that of the Laguna santero, however, suggest that he trained under or was apprenticed to the Laguna santero. Most of the work in this style is in retablo form, although a small number of bultos have been attributed to the same artist. This artist was first known as the "Chili Painter," owing to his use of red, chili-like space fillers, such as those shown in his image of St. Anthony.

San Francisco de Asís / St. Francis of Assisi
Molleno, New Mexico, 1815–45.
Gesso and water-soluble paint on wood, 14⅝ × 9¾ in., SCAS

The santero Molleno has been identified through the inscription penciled on the back of this retablo: "San Francisco pi[n]tado en el año de 1845 por el escultor Molleno" (St. Francis painted in the year 1845 by the sculptor Molleno).

San Antonio / St. Anthony
Style of Molleno, New Mexico, 1815–45.
Gesso and water-soluble paint on wood, 10⅞ × 7⁷⁄₁₆ in., CDC

St. Anthony was born in the year 1195 in Portugal. As a young man, he joined the Franciscan Order and became such an excellent preacher that he was sent to work among the heretics in northern Italy. He died at the age of thirty-six. He is recognized by his blue Franciscan habit with knotted cord and tonsure, which is the circular haircut worn by monks to symbolize the crown of thorns. He usually carries the infant Jesus, who appeared to him in a vision. He may also hold a book or a quill pen, symbols of his learnedness and preaching.

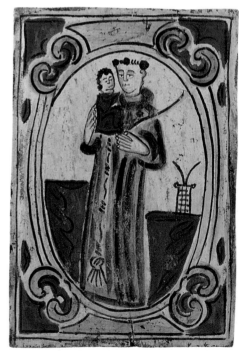

San Miguel, Arcángel /
St. Michael, Archangel
José Aragón, New Mexico,
1820–35.
Gesso and water-soluble paint on
wood, 28 × 15¾ in., SAR

St. Michael is one of the three arch
angels mentioned by name in the
Old Testament. He is the angel of
judgment who clears the way for the
Second Coming of Christ at the
end of the world. In this image,
St. Michael is shown carrying a
standard, symbol of his position
as messenger of God, and a pair
of scales that are used to weigh
the souls on Judgment Day. St.
Michael is the warrior angel and
the Guardian of Heaven.

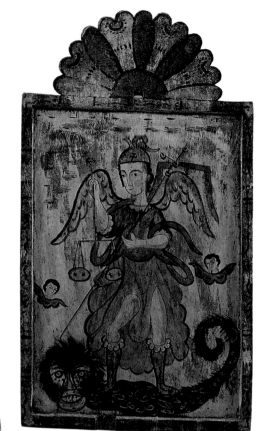

❋ JOSÉ ARAGÓN ❋

José Aragón was probably one of
the more educated santeros of his
time. He possibly was born in
Spain and moved to New Mexico
around 1820; his dated works range
from 1821 to 1835. He signed,
dated, and inscribed many of his
works, and his range of subject
matter indicates the use of numer-
ous printed resources. Some of his
signed works suggest that he had a
workshop where numerous retablos
and bultos were probably produced
under his guidance, although not
necessarily by his hand. He pro-
duced many small retablos, but
only two known altar screens are
attributed to him, both at the san-
tuario in Chimayó. Aragón's figures
are usually well proportioned and
set within a linear border.

Crucifixión / Crucifixion
José Aragón, New Mexico, 1820–35.
Gesso and water-soluble paint on wood,
11½ × 6½ in., CW

Known as "the Crucifixion," this image
always shows Christ crucified with the
mourning figures of the Blessed Virgin Mary
and St. John the Evangelist. This image has
multiple prototypes in renaissance and ba-
roque art from both Europe and Mexico, and
prints of the Crucifixion were disseminated
widely throughout New Spain.

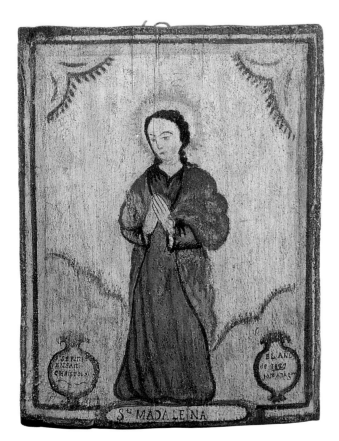

Santa Magdalena / St. Mary Magdalen
José Aragón, San Cristóbal, New Mexico,
1821 or 1827.
Gesso and water-soluble paint on wood,
15¾ × 12 in., IFAF

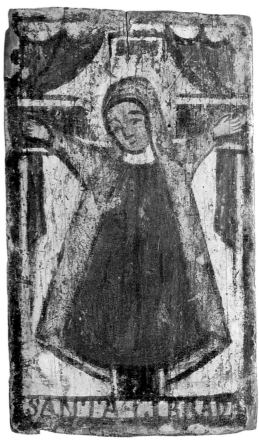

Santa Librada / St. Liberata
School of José Aragón, New Mexico, 1820–40.
Gesso and water-soluble paint on wood, 5 × 3 in.,
SCAS

Santa Librada is a legendary saint of the third century. Her father, the King of Portugal, wanted her to marry the King of Sicily. Santa Librada, however, had chosen to convert to Christianity and had taken a vow of chastity. When she prayed for help, she miraculously grew a beard, which scared her suitor away. Her enraged father had her crucified. In northern Europe, images of Santa Librada show her bearded, but in Spain, Mexico, and New Mexico she is recognized as the only crucified female saint.

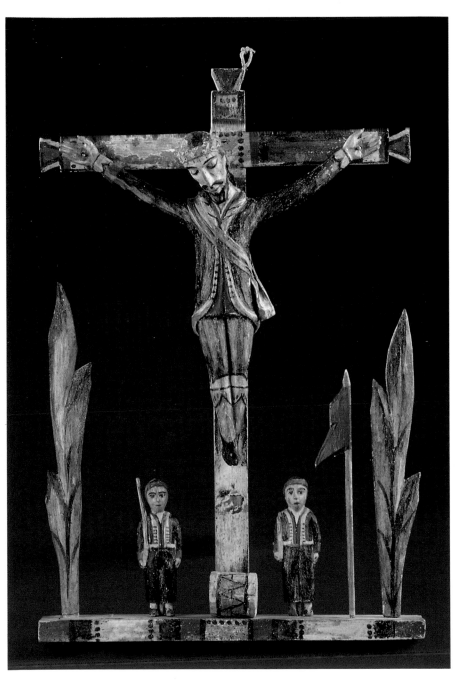

One of the most prolific santeros of the early 19th century, José Rafael Aragón lived in Santa Fe and after about 1832 in nearby Cordova (Wroth 1979). Several of his works have been either signed or dated, among them the image of St. Cajetan shown on page 38. His documented career as a santero, a maker of bultos, retablos, and several major altar screens, spans some forty years, from about 1820 to his death in 1862. Aragón apparently had a number of followers who imitated his distinctive style. His figures are usually well proportioned and, although two dimensional, there is a suggestion of modeling in the faces, particularly around the characteristically almond-shaped eyes.

San Acacio / *St. Achatius*
*Attributed to Rafael Aragón
(ca. 1796–1862), New Mexico,
1820–62.
Gesso and water-soluble paint on
wood, 23¼ × 15⅜ × 2³⁄₁₆ in.,
HSNM*

St. Achatius is said to have lived in the 2nd century A.D. A Roman soldier, he and ten thousand followers converted to Christianity, were persecuted and martyred. In New Mexico, St. Achatius is always depicted as a crucified soldier and is often shown with several smaller, attendant soldiers at his feet.

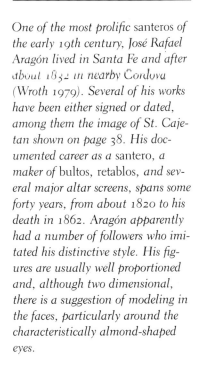

Santo Niño Entronado / Christ Child
 Enthroned
Rafael Aragón (ca. 1796–1862), New
 Mexico, 1820–62.
Gesso and water-soluble paint on wood,
 H: 22¾ in., MNM

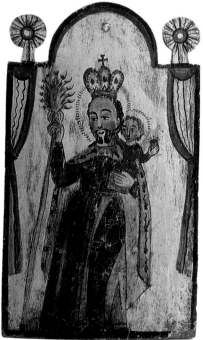

San José / St. Joseph
Rafael Aragón (ca. 1796–1862),
 New Mexico, 1820–62.
Gesso and water-soluble paint on wood,
 23 × 13⅜ in., SAR

In one of the legends about the Blessed Vir-
gin Mary's betrothal, the High Priest of
Judaea assembled all the widowers of the
land and asked each of them to put a staff
upon the altar of the temple. When Joseph, a
carpenter, placed his staff on the altar, it mi-
raculously bloomed, indicating that he was
divinely chosen to be the husband of Mary.
Joseph's attributes consist of a flowering staff
in one hand and the Christ Child on the
other arm. He is also usually bearded and
crowned.

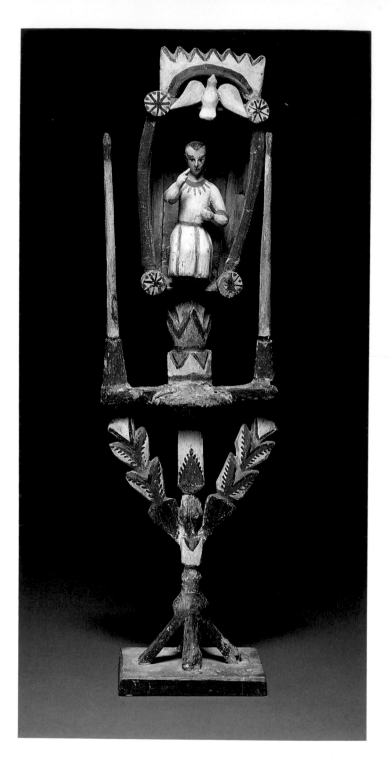

Santa Teresa de Avila / St. Theresa
of Avila
Rafael Aragón (ca. 1796–1862),
New Mexico, 1820–62.
Gesso and water-soluble paint on
wood, H 15⅛ in., cw

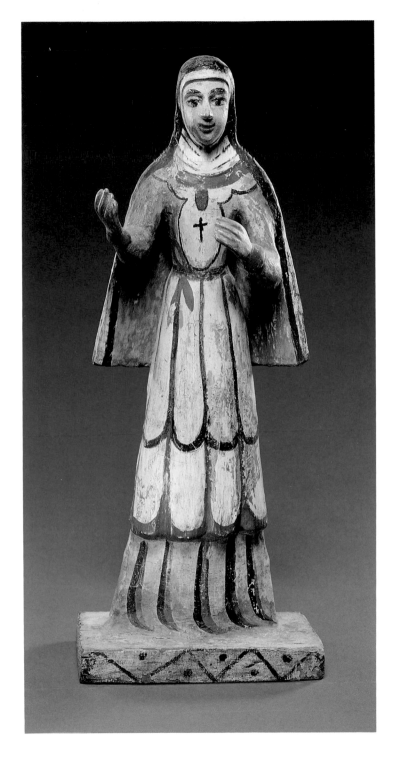

La Huida a Egipto / The Flight into Egypt
Rafael Aragón (ca. 1796–1862), New
Mexico, 1820–62.
Gesso and water-soluble paint on wood,
20½ × 8¾ in., CDC

❋ SANTO NIÑO ❋

The anonymous artist called the Santo Niño santero—because of the numerous images he sculpted of the Holy Child—worked in New Mexico between the 1830s and 1850s. There are no known altar screens by this santero; he seems to have concentrated on carving images and painting small panels. His art shares many characteristics with that of Rafael Aragón, suggesting that the two artists may have been in the same workshop or trained with one another.

Nuestra Señora del Carmen / Our Lady of Mount Carmel
Santo Niño Santero, New Mexico, 1830–60.
Gesso and water-soluble paint on wood, 11 1/16 × 9 3/4 in., SCAS

This image shows the Blessed Virgin Mary as the patroness of the Carmelite Order. She offers the scapular—the badge of lay members of the order—to souls in Purgatory as a symbol of salvation. She is crowned and holds the infant Jesus on her left arm and the scapular in her right hand. The Christ Child also offers the scapular.

Santo Niño de Atocha / The Holy Child of Atocha
Santo Niño Santero, New Mexico, 1830–60.
Gesso and water-soluble paint on wood, 9 × 6 3/4 in., CW

Veneration of the Holy Child of Atocha originated in the state of Zacatecas, Mexico, in the 19th century (Lange 1978), but the legend of the Child takes place in Spain in the 9th century when the country was occupied by the Moors. In a prison in the town of Atocha, the Moors held numerous Christian captives. Only children were allowed in to see the prisoners. One day, a child came with a basket of bread and a gourd of water. As he went through the prison, he gave every prisoner some bread and water, yet when he emerged from the prison, both the basket and gourd were still full. Today the Holy Child of Atocha is venerated in New Mexico at the Santuario de Chimayó, where pilgrims come to pray to him.

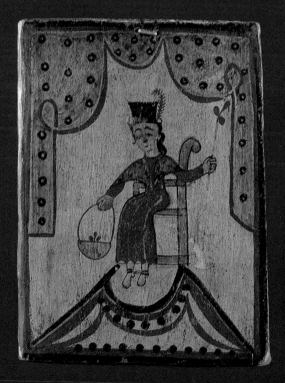

1. Steve Siporin, *American Folk Masters: The National Heritage Fellows* (Santa Fe: Museum of International Folk Art, 1992), 44.

2. France V. Scholes and Lansing B. Bloom, "Friar Personnel and Mission Chronology, 1598–1629," *New Mexico Historical Review* 19, 4 (1944): 335; George Kubler, *The Religious Architecture of New Mexico in the Colonial Period and Since the American Occupation* (Colorado Springs: Taylor Museum, 1940), 7; France V. Scholes, "Documents for the History of the New Mexican Missions in the Seventeenth Century," *New Mexico Historical Review* 4, 1 (1929): 51–58.

3. There are two oldest-known surviving images that were brought to New Mexico by the Spanish and that are still in the state today. The statue of the Blessed Virgin Mary, known as La Conquistadora (and now Our Lady of Peace), was brought by Fray Alonso de Benavides in 1626, was taken with the settlers when they fled to El Paso del Norte (Juárez) during the Pueblo Revolt, and was returned with Don Diego de Vargas in 1693. The medallion from the banner carried by Don Juan de Oñate in 1598 was also returned by Vargas. In Santa Fe, the statue of La Conquistadora remains in her chapel in St. Francis Cathedral while the banner medallion is currently on exhibit at the Palace of the Governors.

4. James E. Ivey, *In the Midst of a Loneliness: The Architectural History of the Salinas Missions*, National Park Service, Southwest Cultural Resources Center Professional Papers No. 15 (1988): 211.

5. France V. Scholes, "The Supply Service of the New Mexico Missions in the Seventeenth Century," *New Mexico Historical Review* 5, 1 (1930): 93–115.

6. France V. Scholes and Eleanor B. Adams, "Inventories of Church Furnishings in Some of the New Mexico Missions, 1672," *University of New Mexico Publications in History* no. 4 (1952): 34.

7. E. Boyd, *Popular Arts of Spanish New Mexico* (Santa Fe: Museum of New Mexico Press, 1974, out of print); Christine Mather, ed., *Colonial Frontiers: Art and Life in Spanish New Mexico, the Fred Harvey Collection* (Santa Fe: Ancient City Press, 1983); Donna L. Pierce, "A History of Hide Painting in New Mexico," unpublished paper, Museum of New Mexico, History Division, p. 9.

8. Frederick Webb Hodge, George P. Hammond, and Agapito Rey, *Fray Alonso de Benavides' Revised Memorial of 1634* (Albuquerque: University of New Mexico Press, Coronado Cuarto Centennial Publications, Vol. 4: 1540–1940, 1945), 67; Eleanor B. Adams, "Bishop Tamarón's Visitation of New Mexico, 1760," *Historical Society of New Mexico Publications in History* 15 (1954): 52; Fray Angélico Chávez, O.F.M., "The Carpenter Pueblo," *New Mexico Magazine* 49 (1971): 26–33; Joseph H. Toulouse, Jr., "The Mission of San Gregorio de Abó," *Monographs of the School of American Research* no. 13 (1949): 23.

9. Charles W. Hackett, ed., *Historical Documents Relating to New Mexico, Nueva Vizcaya, and Approaches Thereto, to 1773*, Vol. 3 (Washington, D.C.: Carnegie Institution, 1937), 72. I am indebted to Cordelia Snow for pointing out this reference to me.

10. Hackett, *Historical Documents Relating to New Mexico*, in 1663, p. 225; in 1665, p. 264; in 1706, p. 370; Fray Francisco Atanasio Domínguez, *The Missions of New Mexico, 1776*, translated and annotated by Eleanor B. Adams and Fray Angélico Chávez (Albuquerque: University of New Mexico Press, 1956), 191; Pierce, "A History of Hide Painting in New Mexico," 10; France V. Scholes, "Church and State in New Mexico, 1610–1650," *Historical Society of New Mexico Publications in History* 7 (1937): 117–27.

11. One such wealthy donor was Don Antonio José Ortiz, who underwrote the reconstruction of San Miguel in Santa Fe and paid for the altar screen at

Nuestra Señora de Guadalupe in Pojoaque; another was Don Francisco Marín del Valle, who funded the construction of La Castrense in Santa Fe. Marsha Clift Bol, "The Anonymous Artist of Laguna and the New Mexican Colonial Altar Screen," master's thesis, University of New Mexico, Department of Art History, Albuquerque, 1980, p. 58; Boyd, *Popular Arts of Spanish New Mexico*; Domínguez, *The Missions of New Mexico, 1776*, 33.

12. Manuel Toussaint, *Colonial Art in Mexico*, translated and edited by Elizabeth Wilder Weismann (Austin: University of Texas Press, 1967), 181.

13. Initially, domes were not constructed in New Mexican churches because there were no skilled stonemasons in the colony. The continued use of the transverse clerestory was probably an economic decision because stonemasons would have to have been brought up from Mexico. There was no tradition of cut stone working among the Native Americans in New Mexico, and there is no evidence of cut stonework in New Mexico other than the altar screen carved for La Castrense, the military chapel on the Santa Fe plaza funded by Don Marín del Valle and attributed to Don Bernardo Miera y Pacheco, who was from Spain. Pueblo buildings in the area that were made out of stone were constructed from stone that was easily broken along a natural fracture and that was not cut or carved. Although some authors state that the transverse clerestory was a solution unique to New Mexico, it had been used previously in Mexico and in Spain (Gloria Giffords, personal communication, 1993).

14. Pierce, "A History of Hide Painting in New Mexico," 14; Thomas J. Steele, S.J., "Francisco Xavier Romero: A Hitherto-Unknown Santero," unpublished paper, Museum of New Mexico, History Division.

15. Marc Simmons and Frank Turley, *Southwestern Colonial Ironwork: The Spanish Blacksmithing Tradition from Texas to California* (Santa Fe: Museum of New Mexico Press, 1980), 32; Lonn Taylor and Dessa Bokides, *New Mexican Furniture, 1600–1940: The Origins, Survival, and Revival of Furniture Making in the Hispanic Southwest* (Santa Fe: Museum of New Mexico Press, 1987), 13.

16. George Kubler, *The Rebuilding of San Miguel at Santa Fe in 1710* (Colorado Springs: Taylor Museum, 1939); Taylor and Bokides, *New Mexican Furniture, 1600–1940*, 14.

17. Domínguez, *The Missions of New Mexico, 1776*, 74.

18. Boyd, *Popular Arts of Spanish New Mexico*; William Wroth, *Christian Images in Hispanic New Mexico: The Taylor Museum Collection of Santos* (Colorado Springs: Taylor Museum of the Colorado Springs Fine Arts Center, 1982); Taylor and Bokides, *New Mexican Furniture, 1600–1940*, 14.

19. Works Progress Administration file 5-5-53, no. 12, Museum of New Mexico History Library: Annette H. Thorp interviewing "Chana" or Cresenciana Atencio in 1940. The interview notes say that Cresenciana was the daughter of embroiderer Policarpio Valencia; however, research by the late E. Boyd indicated that Policarpio's only daughter died shortly after birth (Boyd 1983). Errors in this quote and those following are from the original Federal Writers Project texts as transcribed by Annette H. Thorp and Mrs. Lou Sage Batchen.

20. Henry Glassie, *The Spirit of Folk Art: The Girard Collection at the Museum of International Folk Art* (Santa Fe: Museum of International Folk Art, 1989), 97.

21. Marcus Burke, *Pintura y Escultura en Nueva España: El Barroco* (México: Grupo Azabache, 1992).

22. Thorp interviewing "Chana" or Cresenciana Atencio in 1940.

23. For example, Higinio V. Gonzales (1842–ca. 1922), who lived at San Ildefonso and later moved to Canjilón, was not only a *santero* but a tinsmith, a composer/musician, and a poet as well. Another *santero* who was also a musician as well as a farmer was Miguel Herrera (1835–1905), who lived in Arroyo Hondo, near Taos. Lane Coulter and Maurice

Dixon, *New Mexican Tinwork, 1840–1940* (Albuquerque: University of New Mexico Press, 1990), 59; Cleofas M. Jaramillo, *Shadows of the Past (Sombras del Pasado)* (Santa Fe: Seton Village Press, 1941).

24. William Wroth, *Images of Penance, Images of Mercy: Southwestern Santos in the Late Nineteenth Century* (Norman: University of Oklahoma Press, 1991).

25. Virginia Langham Olmsted, translator and compiler, *New Mexico Spanish and Mexican Colonial Censuses, 1790, 1823, 1845* (Albuquerque: New Mexico Genealogical Society, 1975).

26. Helen R. Lucero, *Hispanic Weavers of North Central New Mexico: Social/Historical and Educational Dimensions of a Continuing Artistic Tradition*, Ph.D. dissertation, University of New Mexico, 1986.

27. Coulter and Dixon, *New Mexican Tinwork, 1840–1940*, 131.

28. While a lot of exchange of goods, traditions, and information, as well as intermarriage, occurred between the Hispanic settlers and the Native American populations of New Mexico, little of this influence has yet been identified in the artwork. Cross-cultural influences have been examined, however, in textiles, and oral traditions today, in the form of stories and songs, do provide information about the interaction and resulting changes between the two cultures. See Joe Ben Wheat, "Río Grande, Pueblo, and Navajo Weavers: Cross-Cultural Influence," in *Spanish Textile Tradition of New Mexico and Colorado*, edited by Nora Fisher (Santa Fe: Museum of New Mexico Press, 1979), and Enrique Lamadrid and Jack Loeffler, *Los Tesoros del Espíritu: Familia y Fe. A Portrait in Sound of Hispanic New Mexico* (Santa Fe: Museum of International Folk Art, 1989), compact disc.

29. Taylor and Bokides, *New Mexican Furniture, 1600–1940*, 21.

30. The inventory was made during the visit of Don Juan Bautista de Guevara on May 7, 1818; Archives of the Archdiocese of Santa Fe at the New Mexico State Records and Archives, Roll 45, Frames 127–30.

31. Toussaint, *Colonial Art in Mexico*, 158–59; Taylor and Bokides, *New Mexican Furniture, 1600–1940*, 6–9.

32. Donna L. Pierce, "New Mexican Furniture and Its Spanish and Mexican Prototypes," in *The American Craftsman and the European Tradition 1620–1820*, edited by Francis J. Puig and Michael Conforti (Minneapolis: Minneapolis Institute of Arts, 1989), 183–86.

33. Although much of the colonial furniture appears unpainted today, examination of many of the pieces in the collections at the Museum of International Folk Art indicates that a lot of the furniture from the nineteenth century was originally gessoed and painted. Because the pigments were water soluble and because unpainted furniture became more popular in the early twentieth century, the paint has often worn off or been removed (see catalogue photos).

34. This recollection was recorded by Mrs. Lou Sage Batchen on March 27, 1942, at Las Placitas, New Mexico. Her sources were José Gurule, Benino Archibeque, and Concepción Archibeque. Works Progress Administration file 5-5-55, no. 2, Museum of New Mexico History Library.

35. Josiah Gregg, *Commerce of the Prairies*, edited by Max L. Moorhead (Norman: University of Oklahoma Press, 1954), 131.

36. Lansing B. Bloom, "Bourke on the Southwest," *New Mexico Historical Review* 10, 4 (1934): 316.

37. Carmen Espinosa, *Shawls, Crinolines, Filigree: The Dress and Adornment of the Women of New Mexico* (El Paso: University of Texas, Texas Western Press, 1970), 45–50; William Wroth, *Hispanic Crafts of the Southwest* (Colorado Springs: Taylor Museum, 1977), 66–68. The Luna family in Taos was known for its filigree work for four generations, from the 1820s until the 1930s.

38. Simmons and Turley, *Southwestern Colonial Ironwork*, 6–18.

39. Boyd, *Popular Arts of Spanish New Mexico*, 289.

40. Ward Alan Minge, "Efectos del País: A History of Weaving along the Río Grande," in *Spanish Textile Tradition of New Mexico and Colorado*, 26.

41. Lucero, *Hispanic Weavers of North Central New Mexico*.

42. Boyd, *Popular Arts of Spanish New Mexico*; Fisher, *Spanish Textile Tradition of New Mexico and Colorado*.

43. Suzanne MacAulay, *Colcha Embroidery along the Northern Río Grande: The Aesthetics of Cultural Inversion in San Luís, Colorado*, Ph.D. dissertation, University of Pennsylvania, 1992.

44. Wroth, *Images of Penance*; Coulter and Dixon, *New Mexican Tinwork, 1840–1940*; Jaramillo, *Shadows of the Past*; Bainbridge Bunting, *Early Architecture in New Mexico* (Albuquerque: University of New Mexico Press, 1976), 107; Charles L. Briggs, *The Wood Carvers of Córdova, New Mexico: Social Dimensions of an Artistic "Revival"* (Albuquerque: University of New Mexico Press, 1980), 31–35.

45. Suzanne Baizerman, "The Transitional Period in Northern New Mexico Hispanic Weaving as Documented in the Files of J. S. Candelario, Santa Fe Curio Dealer (1901 to 1914)," paper presented at the Annual Meeting of the American Society for Ethnohistory, Charleston, South Carolina, November 1986; Sarah Nestor, *The Native Market of the Spanish New Mexican Craftsman: Santa Fe 1933–1940* (Santa Fe: Colonial New Mexico Historical Foundation, 1978); MacAulay, *Colcha Embroidery*; Marta Weigle, ed., "The First Twenty-five Years of the Spanish Colonial Arts Society," in *Hispanic Arts and Ethnohistory in the Southwest: New Papers Inspired by the Work of E. Boyd* (Santa Fe: Ancient City Press, 1983), 181–203.

❋ R E F E R E N C E S ❋

Adams, Eleanor B. "Bishop Tamarón's Visitation of New Mexico, 1760." *Historical Society of New Mexico Publications in History* 15 (1954).

Baizerman, Suzanne. "The Transitional Period in Northern New Mexico Hispanic Weaving as Documented in the Files of J. S. Candelario, Santa Fe Curio Dealer (1901 to 1914)." Paper presented at the Annual Meeting of the American Society for Ethnohistory, Charleston, South Carolina, November 1986.

Bloom, Lansing B. "Bourke on the Southwest." *New Mexico Historical Review* 10, 4 (1934): 271–322.

Bol, Marsha Clift. "The Anonymous Artist of Laguna and the New Mexican Colonial Altar Screen." Master's thesis, University of New Mexico, Department of Art History, Albuquerque, 1980.

Boyd, E. "E. Boyd's Working Notes on Policarpio Valencia and His Alabado Embroidery." In *Hispanic Arts and Ethnohistory in the Southwest: New Papers Inspired by the Work of E. Boyd*, edited by Marta Weigle. Santa Fe: Ancient City Press, 1983.

————. *Popular Arts of Spanish New Mexico*. Santa Fe: Museum of New Mexico Press, 1974 (out of print).

Briggs, Charles L. *The Wood Carvers of Córdova, New Mexico: Social Dimensions of an Artistic "Revival."* Albuquerque: University of New Mexico Press, 1980.

Bunting, Bainbridge. *Early Architecture in New Mexico*. Albuquerque: University of New Mexico Press, 1976.

Burke, Marcus. *Pintura y Escultura en Nueva España: El Barroco*. México: Grupo Azabache, 1992.

Carrillo, Charles, and Felipe Mirabal. Personal communication, 1993.

Cash, Marie Romero. "Santos of the Northern New Mexico Village Churches: A Documentation Project." *El Palacio* 95, 2 (1990): 24–29.

Chávez, Fray Angélico, O.F.M. "The Carpenter Pueblo." *New Mexico Magazine* 49 (1971): 26–33.

Cornelius, F. duPont. "Restoration Notes on Certain Spanish Colonial Paintings in Santa Fe." In *Hispanic Arts and Ethnohistory in the Southwest: New Papers Inspired by the Work of E. Boyd*, edited by Marta Weigle. Santa Fe: Ancient City Press, 1983.

Coulter, Lane, and Maurice Dixon. *New Mexican Tinwork, 1840–1940*. Albuquerque: University of New Mexico Press, 1990.

Domínguez, Fray Francisco Atanasio. *The Missions of New Mexico, 1776*, translated and annotated by Eleanor B. Adams and Fray Angélico Chávez. Albuquerque: University of New Mexico Press, 1956.

Espinosa, Carmen. *Shawls, Crinolines, Filigree: The Dress and Adornment of the Women of New Mexico*. El Paso: University of Texas, Texas Western Press, 1970.

Fisher, Nora, ed. *Spanish Textile Tradition of New Mexico and Colorado*. Santa Fe: Museum of New Mexico Press, 1979.

Gavin, Robin Farwell, Barbara B. Mauldin, and Helen R. Lucero. "History and Iconography of the Architecture and Art at Nuestra Señora del Rosario Church, Truchas, New Mexico." Manuscript on file at the Museum of International Folk Art and the Archdiocese of Santa Fe, 1990.

Giffords, Gloria. Personal communication, 1993.

Glassie, Henry. *The Spirit of Folk Art: The Girard Collection at the Museum of International Folk Art*. Santa Fe: Museum of International Folk Art, 1989.

Gregg, Josiah. *Commerce of the Prairies*, edited by Max L. Moorhead. Norman: University of Oklahoma Press, 1954.

Hackett, Charles W., ed. *Historical Documents Relating to New Mexico, Nueva Vizcaya, and Approaches Thereto, to 1773*. Vol. 3. Washington, D.C.: Carnegie Institution, 1937.

Hodge, Frederick Webb, George P. Hammond, and Agapito Rey. *Fray Alonso de Benavides' Revised Memorial of 1634*. Albuquerque: University of New Mexico Press, Coronado Cuarto Centennial Publications, Vol. 4: 1540–1940, 1945.

Ivey, James E. *In the Midst of a Loneliness: The Architectural History of the Salinas Missions*. National Park Service, Southwest Cultural Resources Center Professional Papers No. 15, 1988.

Jaramillo, Cleofas M. *Shadows of the Past (Sombras del Pasado)*. Santa Fe: Seton Village Press, 1941.

Kubler, George. *The Rebuilding of San Miguel at Santa Fe in 1710*. Colorado Springs: Taylor Museum, 1939.

————. *The Religious Architecture of New Mexico in the Colonial Period and Since the American Occupation*. Colorado Springs: Taylor Museum, 1940.

Lamadrid, Enrique, and Jack Loeffler. *Los Tesoros del Espíritu: Familia y Fe. A Portrait in Sound of Hispanic New Mexico*. Santa Fe: Museum of International Folk Art, 1989 (compact disc).

Lange, Yvonne. "Santo Niño de Atocha: A Mexican Cult Is Transplanted to Spain." *El Palacio* 84, 4 (1978): 2–7.

Lucero, Helen R. *Hispanic Weavers of North Central New Mexico: Social/Historical and Educational Dimensions of a Continuing Artistic Tradition*. Ph.D. dissertation, University of New Mexico, 1986.

————. "Hispanic Weaving of North Central New Mexico: An Overview." Paper presented at the American Folklore Society Conference, Albuquerque, October 23, 1987.

MacAulay, Suzanne. *Colcha Embroidery along the Northern Río Grande: The Aesthetics of Cultural Inversion in San Luis, Colorado*. Ph.D. dissertation, University of Pennsylvania, 1992.

Mather, Christine, ed. *Colonial Frontiers: Art and Life in Spanish New Mexico, the Fred Harvey Collection*. Santa Fe: Ancient City Press, 1983.

Minge, Ward Alan. "Efectos del País: A History of Weaving along the Río Grande." In *Spanish Textile Tradition of New Mexico and Colorado*, edited by Nora Fisher. Santa Fe: Museum of New Mexico Press, 1979.

Nestor, Sarah. *The Native Market of the Spanish New Mexican Craftsman: Santa Fe 1933–1940*. Santa Fe: Colonial New Mexico Historical Foundation, 1978.

Olmsted, Virginia Langham, translator and compiler. *New Mexico Spanish and Mexican Colonial Censuses, 1790, 1823, 1845*. Albuquerque: New Mexico Genealogical Society, 1975.

Pierce, Donna L. "A History of Hide Painting in New Mexico." Unpublished paper, Museum of New Mexico, History Division.

———. "New Mexican Furniture and Its Spanish and Mexican Prototypes." In *The American Craftsman and the European Tradition 1620–1820*, edited by Francis J. Puig and Michael Conforti. Minneapolis: Minneapolis Institute of Arts, 1989.

Pierce, Donna, and Marta Weigle, eds. *Spanish New Mexico: The Collections of the Spanish Colonial Arts Society*. Santa Fe: Spanish Colonial Arts Society, in press.

Scholes, France V. "Church and State in New Mexico, 1610–1650." *Historical Society of New Mexico Publications in History* 7 (1937): 117–27.

———. "Documents for the History of the New Mexican Missions in the Seventeenth Century." *New Mexico Historical Review* 4, 1 (1929): 45–58; no. 2: 195–201.

———. "The Supply Service of the New Mexico Missions in the Seventeenth Century." *New Mexico Historical Review* 5, 1 (1930): 93–115.

Scholes, France V., and Eleanor B. Adams. "Inventories of Church Furnishings in Some of the New Mexico Missions, 1672." *University of New Mexico Publications in History* no. 4 (1952): 27–38.

Scholes, France V., and Lansing B. Bloom. "Friar Personnel and Mission Chronology, 1598–1629." *New Mexico Historical Review* 19, 4 (1944): 319–36.

Simmons, Marc, and Frank Turley. *Southwestern Colonial Ironwork: The Spanish Blacksmithing Tradition from Texas to California*. Santa Fe: Museum of New Mexico Press, 1980.

Siporin, Steve. *American Folk Masters: The National Heritage Fellows*. Santa Fe: Museum of International Folk Art, 1992.

Sobré, Judith Berg. *Behind the Altar Table: The Development of the Painted Retable in Spain, 1350–1500*. Columbia: University of Missouri Press, 1989.

Steele, Thomas J., S.J. "Francisco Xavier Romero: A Hitherto-Unknown Santero." Unpublished paper, Museum of New Mexico, History Division.

Taylor, Lonn, and Dessa Bokides. *New Mexican Furniture, 1600–1940: The Origins, Survival, and Revival of Furniture Making in the Hispanic Southwest*. Santa Fe: Museum of New Mexico Press, 1987.

Toulouse, Joseph H., Jr. "The Mission of San Gregorio de Abó." *Monographs of the School of American Research* no. 13 (1949).

Toussaint, Manuel. *Colonial Art in Mexico*, translated and edited by Elizabeth Wilder Weismann. Austin: University of Texas Press, 1967.

Turner, Kay Frances. *Mexican-American Women's Home Altars: The Art of Relationship*. Ph.D. dissertation, University of Texas, Austin, 1990.

Vedder, Alan. "El Arte de la Iglesia de Santa Cruz." In *La Iglesia de Santa Cruz de la Cañada*, edited by Jim Sagel. Santa Cruz: Parish of Santa Cruz, 1983.

von Wuthenau, A. "The Spanish Military Chapels in Santa Fe and the Reredos of Our Lady of Light." *New Mexico Historical Review* 10, 3 (1935): 175–94.

Weber, Michael. "Filigree Jewelry of New Mexico." *El Palacio* 88, 4 (1982–83): 39–47.

Weigle, Marta, ed. "The First Twenty-five Years of the Spanish Colonial Arts Society." In *Hispanic Arts and Ethnohistory in the Southwest: New Papers Inspired by the Work of E. Boyd*. Santa Fe: Ancient City Press, 1983.

Wheat, Joe Ben. "Río Grande, Pueblo, and Navajo Weavers: Cross-Cultural Influence." In *Spanish Textile Tradition of New Mexico and Colorado*, edited by Nora Fisher. Santa Fe: Museum of New Mexico Press, 1979.

Wroth, William. *The Chapel of Our Lady of Talpa*. Colorado Springs: Taylor Museum of the Colorado Springs Fine Arts Center, 1979.

———. *Christian Images in Hispanic New Mexico: The Taylor Museum Collection of* Santos. Colorado Springs: Taylor Museum of the Colorado Springs Fine Arts Center, 1982.

———. *Hispanic Crafts of the Southwest*. Colorado Springs: Taylor Museum, 1977.

———. *Images of Penance, Images of Mercy: Southwestern* Santos *in the Late Nineteenth Century*. Norman: University of Oklahoma Press, 1991.

Ybarra-Frausto, Tomas. "The Chicano Movement/The Movement of Chicano Art." In *Exhibiting Cultures: The Poetics and Politics of Museum Display*, edited by Ivan Karp and Steven D. Lavine. Washington, D.C.: Smithsonian Institution Press, 1991.